POSTCARD HISTORY SERIES

South Boston

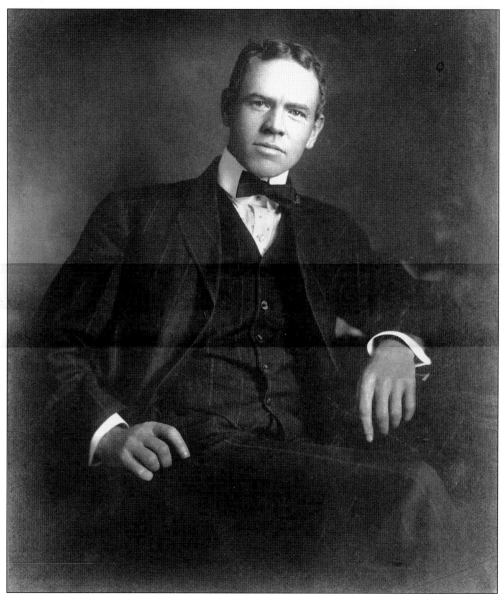

James Brendan Connolly's performance in the triple jump earned first place in the 1896 revival of the Olympic Games in Athens; four years later, he took the silver medal in the same event in Brussels. Though remembered chiefly for his athletic prowess, Connolly later became a highly regarded novelist specializing in stories of men at sea. In a 1953 *New York Times* review of an anthology of classic novelettes and short stories, literary critic Orville Prescott singled out Connolly's contribution for special praise: "One of the finest stories in the collection is a superb tale of the Gloucester fishing fleet, 'The Trawler', by James Brendan Connolly, a masterpiece of local color and heroic action." (Courtesy of Colby College Special Collections.)

On the front cover: Please see page 14. (Author's collection.)

On the back cover: Please see page 76. (Author's collection.)

POSTCARD HISTORY SERIES

South Boston

Jim Sullivan

ARCADIA
PUBLISHING

Published by Arcadia Publishing
Charleston SC, Chicago IL, Portsmouth NH, San Francisco CA

Printed in the United States of America

Library of Congress Catalog Card Number: 2007930873

For all general information contact Arcadia Publishing at:
Telephone 843-853-2070
Fax 843-853-0044
E-mail sales@arcadiapublishing.com
For customer service and orders:
Toll-Free 1-888-313-2665

Visit us on the Internet at www.arcadiapublishing.com

*To my mother and father, Catherine and James, my wife, Rita,
and our daughters, Erin, Kerry, and Shannon*

CONTENTS

ACKNOWLEDGMENTS

This book was made possible with the cooperation of many others, including, but not limited to, the following: former Boston fire commissioner/chief of department Paul Christian, not only for the wealth of information he provided but also for giving of his time and expertise in proofreading my original manuscript; my colleagues at South Boston High School, Bob Healey and Mike Ritz, both of whom gave generously of their time and contributed postcards and other artifacts from their personal collections; fellow collector Joe Williams, several of whose postcards and photographs grace these pages; the late Dr. William Reid, former headmaster of South Boston High School, and his daughter, Pat; Dr. Thomas H. O'Connor of Boston College, whose books and encouragement were most helpful; James Barry, who is Michael J. Perkins's nephew, and Tom Mulkern and Alicia Mulkern Hawkes, Perkins's cousins, for materials they provided on the Medal of Honor recipient; ever-reliable Andrew Puleo of the Boston Public Schools Planning and Engineering Department; Jeanne Gamble and Emily Gustainis of the New England Society for the Preservation of New England Antiquities; Marion O'Donnell, grandniece of James Brendan Connolly, and Pat Burdick of Colby College for information and photographs of the Olympic athlete; John Dorfey of the Boston Public Library, without whose volitional intervention the newspaper pages herein could not have been included; Jan Seymour-Ford of the Perkins Institute for the Blind; the staff of the Boston Public Library, Aaron Schmidt in particular, who are to be commended for their expertise, efficiency, and willingness to quickly and courteously assist the technologically challenged; John Sheehan of the Public Facilities Department at city hall in Boston, still the most capable and dedicated of public servants after 48 years; Sean Fischer of the Department of Conservation and Recreation; Roysin Bennett Younkin of the Boston Landmarks Commission; state transportation archivist Leo Sullivan; Rebecca Reynolds; Cynthia Dromgoole of the South Boston branch of the Boston Public Library; Robert Lifson of Robert Edward Auctioneers; Steve Mulrey of Amrhein's; Bill Spain of the Castle Island Association; Patricia Kelly, photograph archivist of the National Baseball Hall of Fame in Cooperstown; Wendy Hurlock-Baker of the Smithsonian Institute; Terrace Winschel of the Vicksburg National Military Park; Bill Martin of Mary Martin Postcards; my brother, Brian, for taking the accompanying photographs; and finally, my editor, Erin Stone, who patiently restrained my penchant for prolixity. My heartfelt thanks to you all.

INTRODUCTION

I am often asked how I started collecting old Southie postcards, and I remember very clearly the first two postcards I purchased. I had attended a Sunday afternoon antique show at Broad Cove Hall in Hingham in 1998 when my eye was drawn to a pair of color postcards lying face up on a dealer's table. The first was a picture of Kelly's Landing (then known as the Public Landing) with the Head House in the background, very similar to the card that graces the cover of this book, the other a crowded beach scene. Let me add parenthetically that this was hardly my first exposure to Southie postcards—in the 1960s, Slocum's sold contemporary postcards of Broadway, the beach, and other local scenes, but they were black and white and held little interest for me. In the early 1980s, someone, possibly Stretch Walsh or, more likely, Eddie Rull, put up a grainy, enlarged photograph of a postcard of the L Street Bathhouse in the lobby of the L. But this card, too, had little aesthetic appeal. The postcards that I had serendipitously discovered at the antique show were in an altogether different class. For one thing, these cards were much older—people's clothing dated the cards to 1910 or so. Also, the cards were beautifully colored and that really intrigued me, seeing hand-tinted photographs from that era. I honestly experienced the feeling that I had stepped back in time. I stared at the images intently, thinking that Kelly's and the Head House were gone and were not coming back, and I realized that I was holding two 3½-by-5-inch pieces of history. The dealer wanted $2 apiece for the cards, if memory serves, which I happily paid. After that, I became an avid collector and have accumulated a collection that today numbers over 300 cards.

Postcard collecting goes back well over 100 years and was especially popular from the early 1900s until World War I. In 1913 alone, at the peak of interest, Americans bought 968 million cards. The use of postcards originated in Austria and spread throughout Europe and then to this country, the first American postcards being issued by the United States Post Office in 1873. By the end of the 19th century, publishers were producing cards featuring a variety of subjects: political scenes, holidays, such as Christmas and Valentine's Day, transportation, industry, landscapes, seascapes, cityscapes, monuments, and scenes of daily life. In 1898, the Detroit Publishing Company secured exclusive rights to the Swiss Photochrom procedure for lithographically adding layers of color to black-and-white images. With this competitive advantage, it became the preeminent publisher of postcards in the United States for the succeeding two decades, although it had many competitors. These pre–World War I cards are the most sought after by collectors today.

All of the postcards in this book were produced during the following periods:

Undivided-back period (1901–1907)—writing was confined to the blank area on the front of the card as the back was reserved for addresses and postage; the lower card on page 73 is an example.

Divided-back era (1907–1914)—writing was permitted on the back of the card; generally speaking, the image on the face of the card filled the entire surface. Most cards were printed in Germany at this time. See pages 9 and 10 for examples.

White-border era (1915–1930)—the majority of cards from this period were printed in America as the likelihood of war with Germany increased. Publishers left a white border around the perimeter of the card to conserve ink. Page 15 displays two examples.

Linen period (1930–1944)—publishers used coarser paper with higher rag content and very bright, almost garish colors. The bottom card on page 115 is one of the two linen cards that appear in this book.

In addition to educating Americans by exposing them to views of places they had never been, postcards served a more practical function. In the days before the telephone became a fixture in most homes, postcards were a cheap and expeditious way of communicating with relatives and friends who were some distance removed. It cost only a penny to mail a postcard, half the 2¢ required to mail a sealed envelope. Travelers and vacationers bought them as souvenirs of their sojourns to maintain a visual record of their itineraries. Many people bought postcards with no intention of mailing them, but simply to store in albums to share with others. But the fad ran its course, and postcards began to fall out of favor with the outbreak of war and widespread usage of the telephone. It was not until the 1970s that there was a resurgence of interest and postcards were appreciated as an art form.

In response to questions that I am frequently asked, the first of which is, "Where do you find them?" the answer would be: postcard dealers can generally be found at antique shows, and there are postcard shows held locally as well. Be advised, however, that dealers typically combine Southie postcards with cards from Dorchester, Jamaica Plain, East Boston, Hyde Park, and other Boston neighborhoods, so a considerable investment in time may be required to separate the wheat from the chaff, so to speak. On the other hand, dealers generally lack a sense of which cards are in high demand and often undervalue rare cards. A more convenient and accessible source is eBay, but these cards tend to be more expensive because collectors must compete against a larger pool of prospective buyers, many of whom have deep pockets. Another question I am often asked is, "How much do they cost?" As with any commodity, price is a function of supply and demand, with condition factored in. Postcards can usually be obtained at shows for $2 to $10; common cards typically sell on eBay for $4 to $10, and one can build an extensive collection buying cards in this range. Scarce postcards are a different story though, as one is invariably bidding against very determined buyers. These items may sell for an amount in excess of $40 or even $50. To the best of my recollection, the most expensive South Boston card to sell on eBay in the last five or six years brought $80, but this is quite exceptional. As to the question of how many postcards of South Boston exist, I would make an estimate of 350–400, though similar cards abound.

Over the years, I have found collecting postcards to be a gratifying and educational diversion; I hope this book imparts the same sense of anticipation and discovery.

Jim Sullivan
August 7, 2007

One

PLEASURE BAY AND
THE HEAD HOUSE

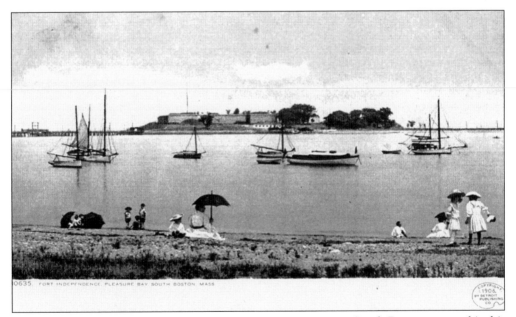

0635. FORT INDEPENDENCE PLEASURE BAY SOUTH BOSTON MASS.

One of the most evocative and timeless images to appear on any South Boston postcard is this tranquil scene of a mother keeping a watchful eye on her children on a sunny afternoon at Pleasure Bay. Were it not for the Victorian garb—flowing skirts, broad hats, and parasols—this picture could have been taken 20 years ago or 20 years hence. The photograph, taken around 1905, is the work of Henry Peabody (1855–1951), an accomplished marine and landscape photographer in the employ of the Detroit Publishing Company from 1902 to 1908. In all likelihood, he is responsible for the photographs depicted on pages 10, 11, 12, and 13 as well.

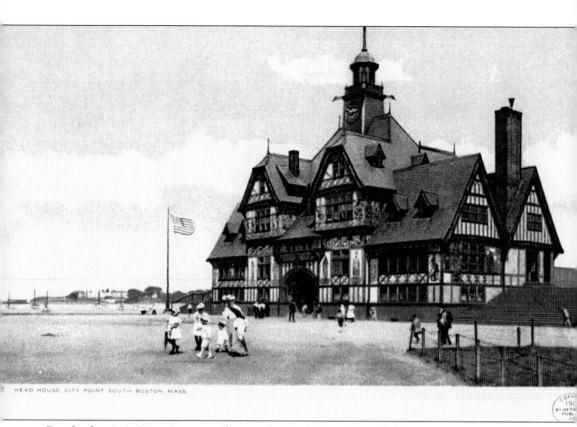

Resplendent in its Victorian magnificence, the Head House (so called because it was positioned at the head of the peninsula) dominates this view from the Strandway. In the foreground, a family (the same, perhaps, as the one shown in the previous postcard?) bedecked in their Sunday finest promenade past the Head House. This photograph can also be attributed to Henry Peabody, about whom it was written, "His work gives the impression that he was interested mainly in places, not people; human beings often seem included as foils to contribute a sense of scale in the breadth and magnificence of nature or the massive solidity of urban scenes."

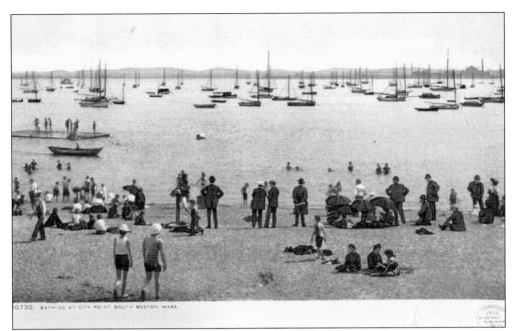

In the early 20th century, families relied on the cool waters of Dorchester Bay to swim, wade, or just catch a refreshing breeze to escape the oppressive summer heat. Bostonians from every neighborhood flocked to City Point via streetcar bearing children, blankets, and parasols. One cannot help but wonder if beachwear was harder to come by in those days.

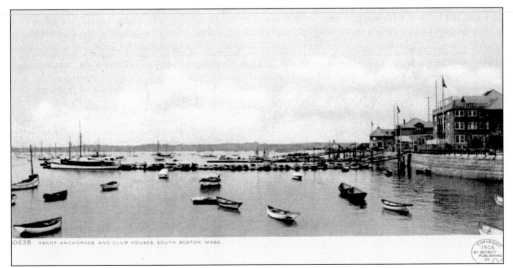

A pier projects into the harbor from the rear of the South Boston Yacht Club as a flotilla of marine craft basks in the shallow water. Formerly located at the foot of P Street, the yacht club impeded the extension of the Strandway (now Day Boulevard) and was rebuilt on its current site in 1899. Constructed on land that had been a salt marsh, the structure is supported by the 12-foot-high granite seawall at right.

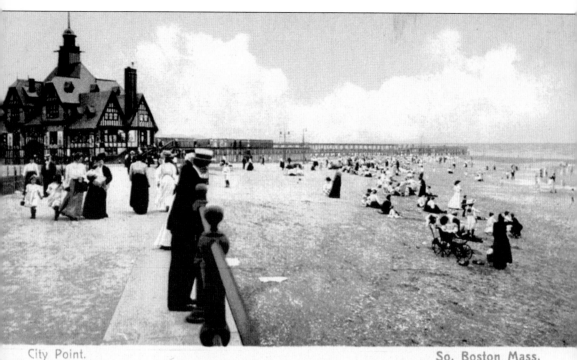

City Point. So. Boston Mass.

Stylishly clothed in sun hats, long-sleeved blouses, and billowing full-length skirts, the women at left converse while attending to their progeny as the Head House looms in the distance. At right, a woman watches over her baby in a perambulator while others take advantage of the receding waters to venture farther from shore. This photograph, too, is probably the work of the prolific Henry Peabody, who, though not a native Bostonian, resided at 497 and 499 Columbus Avenue in the South End and 12 Isabella Street in Bay Village (then called Kerry Village due to the ubiquity of residents who had emigrated from the Irish province) during the 20 years that he lived in this city.

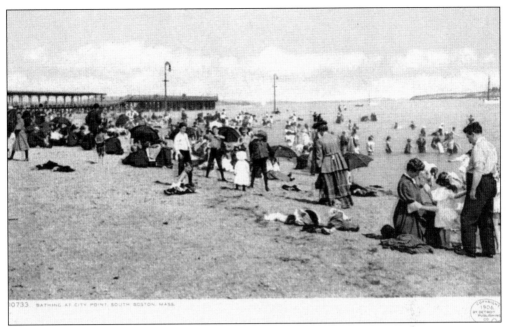

Swimmers, waders, sun worshippers, beachcombers, and children throng the beach in these two cards produced by the Detroit Publishing Company, probably the preeminent publisher of postcards during the first two decades of the 20th century. Established in 1898, the firm secured exclusive rights to the Swiss Photochrom procedure for converting black-and-white images to color. The process involved the use of a lithographic stone for each color, with each print requiring a minimum of 4 to as many as 14 stones. This innovative procedure facilitated the mass production of color postcards and prints for the American public. Intense competition and decreasing sales drove the company into receivership in 1924.

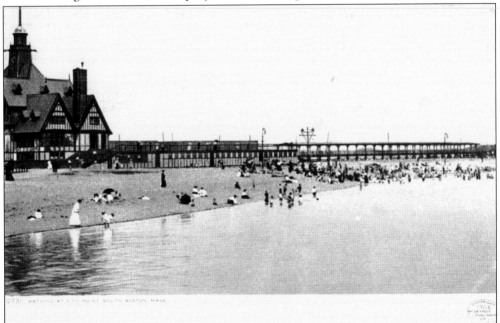

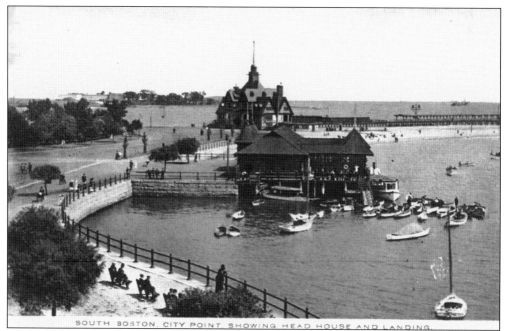

SOUTH BOSTON, CITY POINT, SHOWING HEAD HOUSE AND LANDING.

South Boston postcards are analogous to baseball cards in that there are common and scarce cards. This panoramic view of maritime landmarks, taken about 1914, with the Public Landing in the foreground and the Head House and Castle Island in the distance, is one of the most beautifully composed and frequently encountered of all South Boston postcards. Variations of this card featuring a range of color schemes were produced by many different publishers throughout the first half of the 20th century.

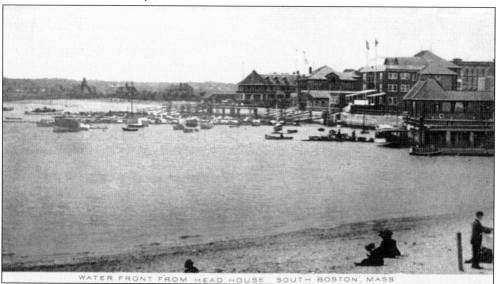

WATER FRONT FROM HEAD HOUSE SOUTH BOSTON, MASS

From this point on the stretch of beach between the Public Landing and the Head House, at right, one can make out the rear of the South Boston Yacht Club, Columbia Yacht Club, Puritan Canoe Club, Boston Yacht Club, and L Street Bathhouse. Continuing to follow the shoreline around to the left, the steeple of the L Street Bathhouse is visible (with the aid of a magnifying glass), as is one of the fences that runs from the rear of the building to the water.

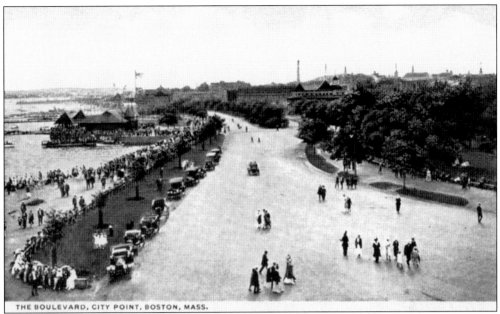

THE BOULEVARD, CITY POINT, BOSTON, MASS.

Judging from this photograph, taken around 1915 from one of the upper floors of the Head House, parking could be a problem in Southie even in the days of the Model T! In a scene from the Sunday rotogravure, automobiles line the Strandway (now Day Boulevard), and fashionably attired pedestrians make their way to Marine Park and Castle Island.

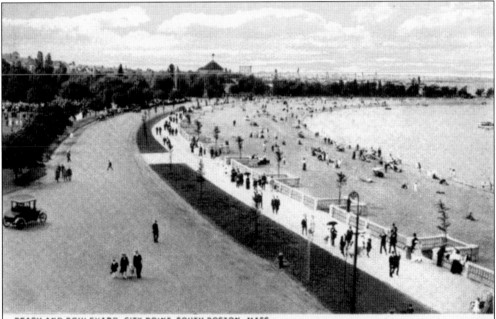

BEACH AND BOULEVARD, CITY POINT, SOUTH BOSTON, MASS.

Aside from the automobile, this scene of pedestrians on the Strandway and bathers in Pleasure Bay, undoubtedly taken the same day as the previous card and from a similar vantage point in the Head House, may look relatively unchanged today. The keen observer will note key differences, however: the conical cupola of the Aquarium is readily evident above the tree line, and the balustrade that separates beach from sidewalk has been replaced with a concrete barrier.

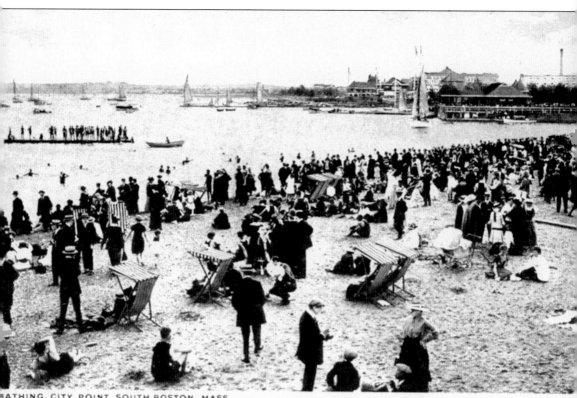

BATHING, CITY POINT, SOUTH BOSTON, MASS.

The appearance of swimmers in the water and on the float at left invites the inference that the mercury is climbing, yet most of these beachgoers are fully clothed. One could reasonably speculate that, in the days before air-conditioning, many Bostonians possessed a higher tolerance for heat and humidity. While perusing postcards that depict congested beaches teeming with masses of humanity, remember that South Boston and the rest of the city were far more populous in the early 1900s. Southie's population peaked at 71,703 in 1910, more than double the current population of just under 30,000. A range of factors—immigration restriction, the postwar development of the interstate highway system and subsequent expansion of the suburbs, greater accessibility to mortgages due to the GI Bill, the declining birth rate, dissatisfaction with the public schools, and escalating housing costs—have combined to significantly diminish the population of Boston and other large urban centers.

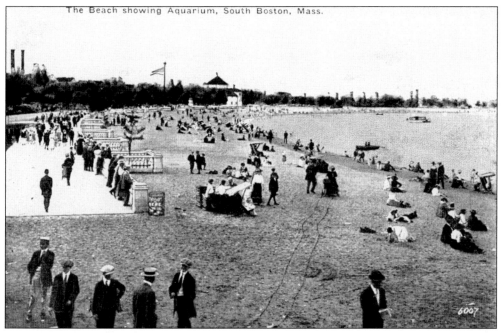

The Beach showing Aquarium, South Boston, Mass.

The juxtaposition of these two postcards demonstrates why the first would be of greater interest to collectors. In the first card, the crescent-shaped shoreline, curvilinear balustraded parapet, and presence of the Aquarium in the background readily identify the setting as Pleasure Bay. By contrast, the second card has few landmarks or geographical features with which to fix the location, though some might recognize the topographical profiles of Spectacle and Thompson's Islands on the horizon. The setting is relatively generic and therefore of less interest to collectors. Note, however, the exceptional clarity of both photographs, including the parallel tracks in the sand from the baby carriage in the upper view.

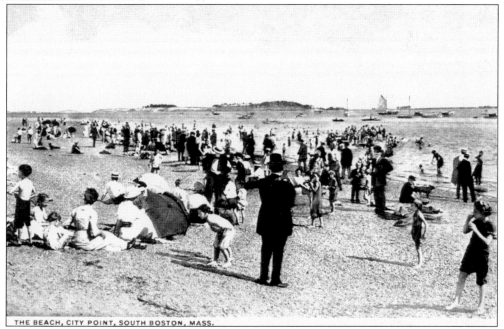

THE BEACH, CITY POINT, SOUTH BOSTON, MASS.

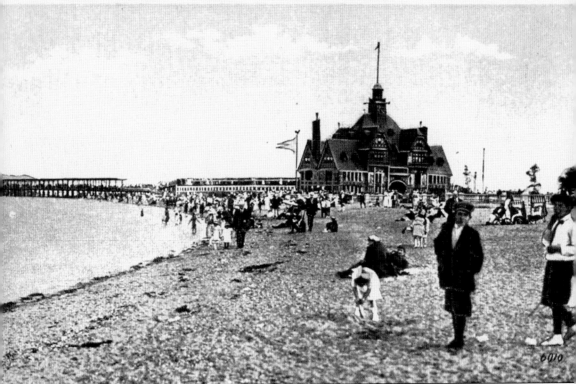

This card, postmarked 1921, also features a coterie of beachgoers taking advantage of the coastal amenities; some are garbed for cooler weather while a few hardier souls venture into shallow water. In his engagingly informative treatise *South Boston, My Home Town: History of an Ethnic Neighborhood*, historian Thomas H. O'Connor documents the fact that as far back as a century ago, residents of Southie took great pride in the beauty of their community and expressed concern about the summertime influx of "Cambridge people" and other lowbrow interlopers. Such laments are heard even to this day; forbearance is the price one must pay for living in a neighborhood so generously endowed by nature.

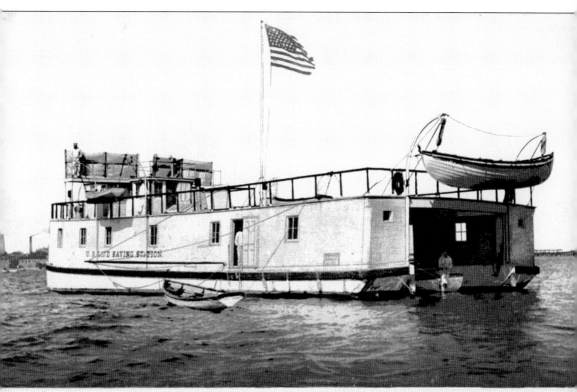

City Point Life Saving Station. Boston Harbor, Mass.

Forty people drowned in Dorchester Bay and Pleasure Bay between 1890 and 1894 alone, and in one particularly tragic 1896 incident, four children drowned when their raft capsized in Pleasure Bay. Alarmed citizens petitioned Congress for a lifesaving station. Their efforts were successful, and $7,000 was appropriated to finance the station, which was constructed in Connecticut, then towed to Boston, arriving on August 3, 1896. One hundred feet long, thirty-three feet beam, and six feet deep, with upper and lower decks, the station comprised a kitchen, dining room, quarters for the 10-man crew, the captain's office and bedroom, and storage. A heavy-surf boat hung at the stern, ready to take action at a moment's notice. From May through November, the station was anchored in Dorchester Bay; in winter it was berthed near Chelsea Bridge.

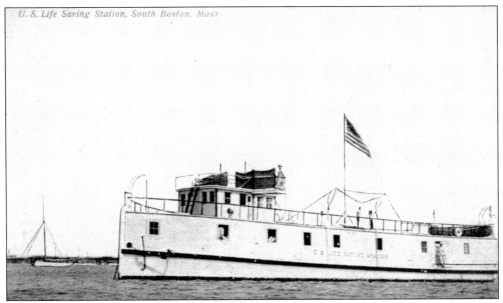

From the beginning, the lifesaving station proved to be an effective device. In 1897, its first full year of operation, 29 swimmers were rescued from drowning. There was only one fatality due to drowning that year, which occurred in Pleasure Bay, out of view of the station. A signal service was then installed at Marine Park so that the station could be notified in case of emergency. Nineteen persons were rescued from drowning in 1898, thirty-three in 1899. Rebuilt in 1913, the station was finally decommissioned by the Coast Guard in 1939.

In rare instances, those who were inclined to do so would produce a postcard using personal photographs, and this card is an example. One wonders if the seasoned citizens pictured here, buffeted by strong winds, ever made it to their destination since, with the water to their left, they appear to be headed in the opposite direction.

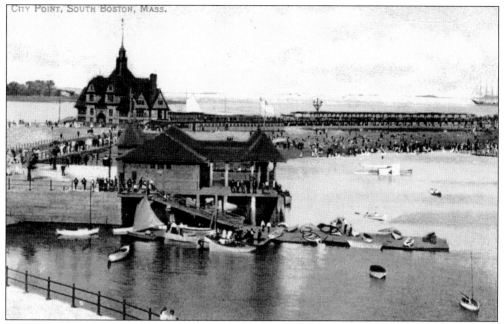

These views of the Public Landing with the Head House beyond were taken from a vantage point similar to that of the upper photograph on page 14. Stationed on the observation deck of the South Boston Yacht Club, the photographer has zoomed in for a tighter view of the landing, which is built on pilings driven into the filled land at the harbor's edge. Both cards were printed in Germany by Robbins Brothers Company, Boston and Germany.

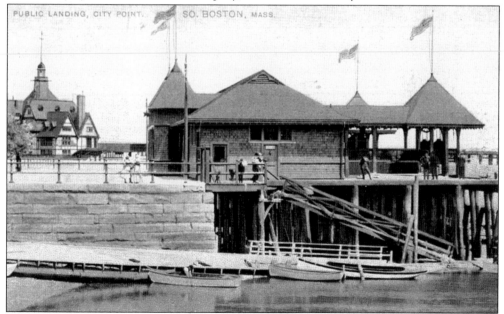

PUBLIC LANDING, CITY POINT. SO. BOSTON, MASS.

In this very rare *c.* 1908 postcard, a sign flanked by the conical turrets of the Public Landing advertises "Steamers / Castle Island / Fare 5 Cents." The Public Landing was the point of departure for sojourns to George's Island, Thompson's Island, and other points of interest in Boston Harbor. The shingled structure was purchased by the Kelly family in 1927 and was thereafter known as Kelly's Landing.

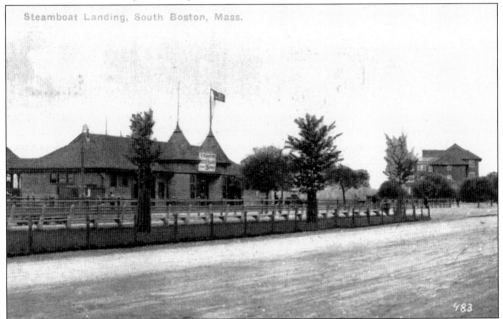

The Public Landing is misidentified on this card, which is postmarked 1914, as the Steamboat Landing; the publisher may have misinterpreted the sign that reads "Steamers" (steamed clams) over the doorway. In this photograph, taken from Marine Park, the saplings springing up from the verdant island on the Strandway impart an almost semitropical ambience.

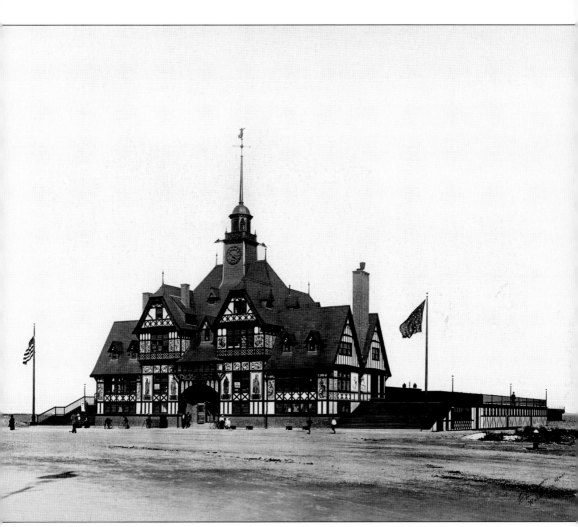

Stunning, spectacular, extravagant, palatial, majestic, opulent, and awe-inspiring—trot out all the descriptive superlatives, yet they seem inadequate to describe the aesthetic qualities of architect Edmund March Wheelwright's Victorian-era masterwork, the Head House. Postcards of South Boston's most visually arresting edifice were exceedingly popular and are therefore among the most commonly encountered by collectors. The assortment presented here is but a sampling of the plethora of cards featuring the Head House that were produced by many different publishers. (Courtesy of Bill Spain, Castle Island Association.)

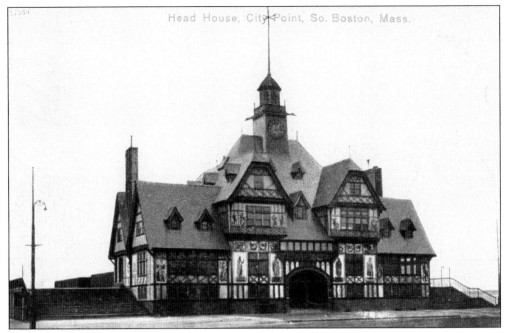

Architect Edmund March Wheelwright modeled the Head House after a neo-German *rathouse*, or municipal building, that was featured at the World's Columbian Exposition, held in Chicago in 1893. Construction of the elaborate wooden structure commenced in 1895, and the building opened to the public on June 17, 1896. An iron pier was built behind it and opened for public use two days later.

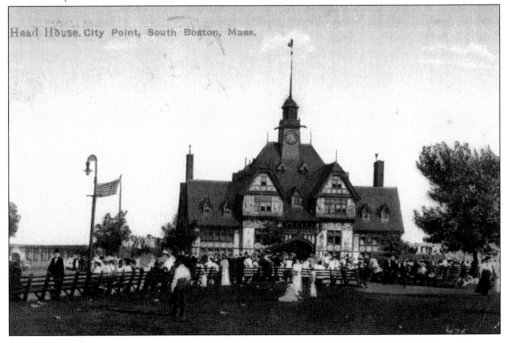

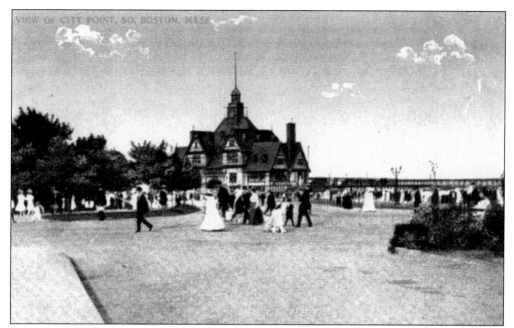

In *The History of South Boston*, published in 1901, authors John J. Toomey and Edward P. B. Rankin describe the Head House as "constructed of wood and . . . two and half stories in height, having double gables on all four sides, the whole being surmounted by a cupola containing a clock, while extending from this is a pinnacle bearing a copper mermaid as a weathervane. The exterior of the building is composed of plastered panels which depict the traditional and historical tale of Massachusetts Bay." The building was flanked on either side by broad flights of steps that connected two large promenade platforms with the new iron pier. Below the platforms, 500 dressing booths were available to bathers and additional space set aside to be used as offices for park officials.

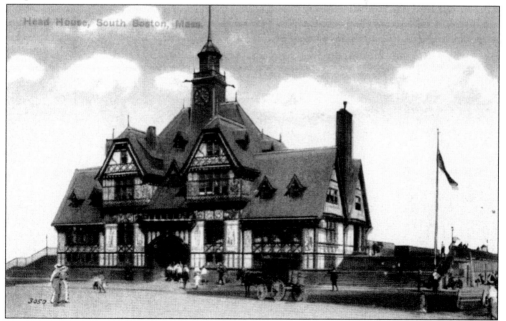

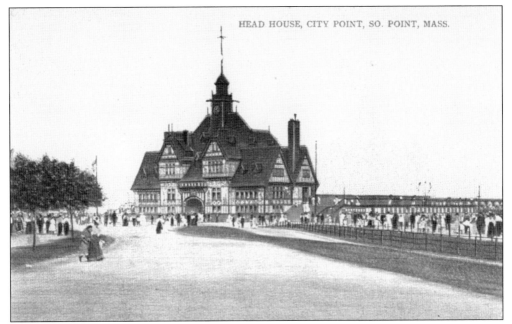

These postcards also feature the Head House, around 1907. The structure included a ground, or terrazzo floor, which comprised a general waiting room, restrooms, and retiring rooms for men and women. Two large cafés and service rooms were located on the second floor, adjacent to the promenades, while the third floor featured a restaurant and kitchen. The bottom card offers a view of the Head House at sunset, quite atypical in that the usual procession of peripatetic traffic has temporarily abated.

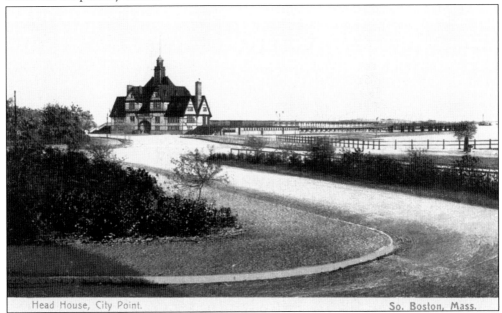

Head House, City Point. So. Boston, Mass.

26

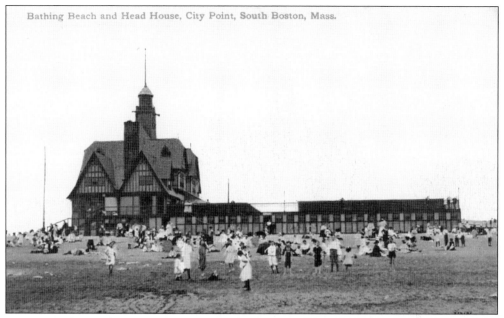

Here again the Head House serves as the backdrop for beach and boating activities. In the early years of the 20th century, families would walk, drive, bicycle, or take the Bay View trolley, at 5¢ per trip, to City Point and Marine Park. From this angle, rows of changing rooms available to beachgoers are clearly visible. Moored offshore in the lower photograph is a gaff-rigged catboat, quite popular in the early decades of the century, probably drying out its sail. (Courtesy of Mike Ritz.)

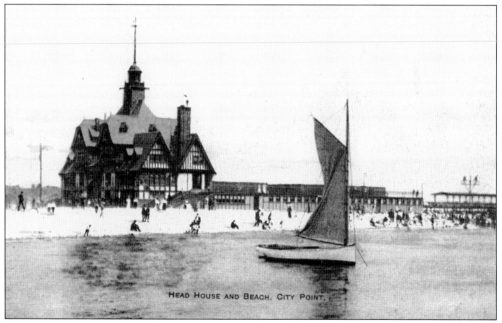

HEAD HOUSE AND BEACH, CITY POINT,

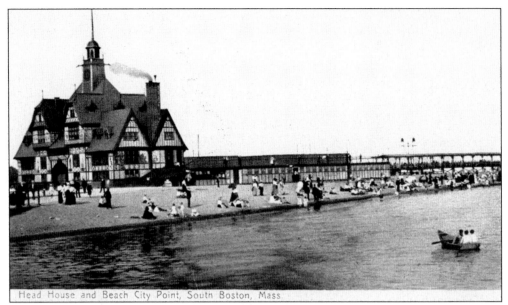

Head House and Beach City Point, South Boston, Mass.

The multitudinous crowds surrounding the neo-German gingerbread palace attest to its powerful attraction to residents of all parts of the city and beyond. This is somewhat ironic given the fact that, in recent decades, this section of the beach has probably been the least utilized of any in South Boston. The top postcard was printed in Germany and distributed by Mason Brothers and Company; the white-border card below was published by A&M of Roxbury and bears a 1921 postmark. (Courtesy of Mike Ritz.)

Waterfront and Head House, South Boston, Mass.

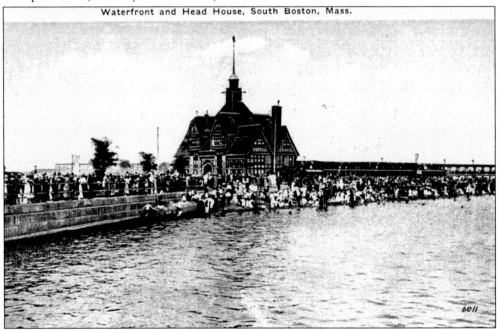

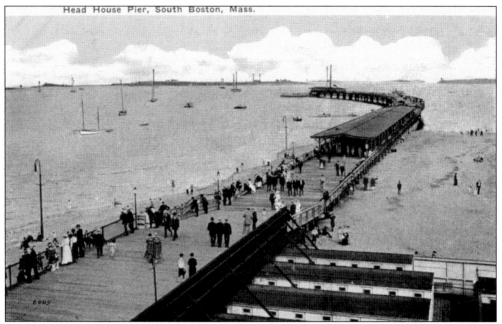

The iron pier behind the Head House extended to Head Island, known colloquially as the "Sugar Bowl," providing strollers with a sunny pathway through the confines of the harbor. The pier was constructed in 1896, available to the public two days after the Head House was opened. Later a 354-foot-long roof was added on in order to provide protection from the elements. The middle section of the pier broke open during the Hurricane of 1938 and was never repaired. The pier was dismantled in the mid-1950s and a solid fill causeway to Head Island installed in 1957.

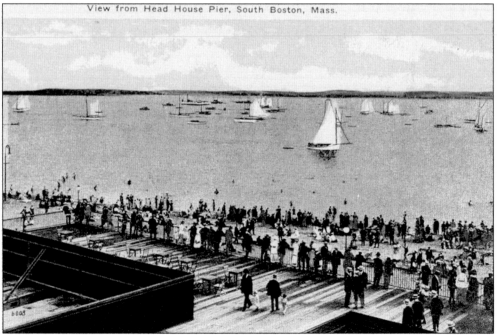

View from Head House Pier, South Boston, Mass.

29

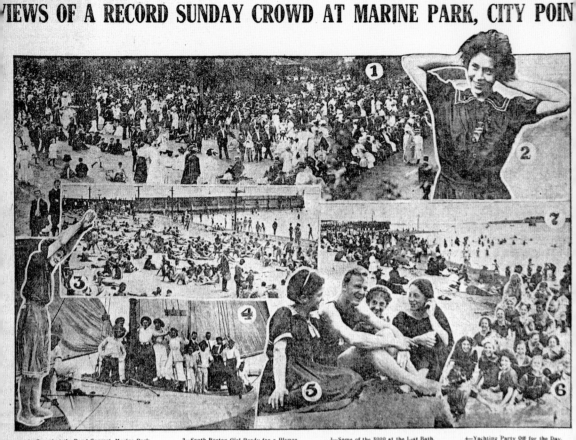

1—Crowd at the Band Concert, Marine Park. 2—South Boston Girl Ready for a Plunge. 3—Some of the 5000 at the L-st Bath. 4—Yachting Party Off for the Day.
5—Group of Bathers Near the Head House. 6—Snapshot in the Women's Section at L st. 7—View Along the Beach.

Even in hindsight, it is easy to underestimate the size of the crowds that flocked to Castle Island, the Head House, and the Aquarium in the years before the prevalence of indoor electronic amusements. Bear in mind that very few Bostonians owned cars in those days and the vast majority relied upon public transportation to travel to other parts of the city. According to contemporary newspaper accounts, as many as 200,000 people in one day would pack the beaches seeking relief from the scorching heat. Headlines from the July 11, 1910, edition of the *Boston Globe* blared, "Record South Boston Crowd; Thousands Wait for Cars Long Time; Fully 150,000 Visitors at City Point." The accompanying article reported on the inability of the transit system to keep up with the surging hordes trying to return home from City Point: "Never has South Boston been so crowded as yesterday and last night [as] it was after midnight . . . The railway company put into service many box cars, but still they were unable to meet the emergency . . . and from 7 to 10 there were 10,000 people on Farragut road, on East 6th st and in the park waiting for a chance to get on a car."

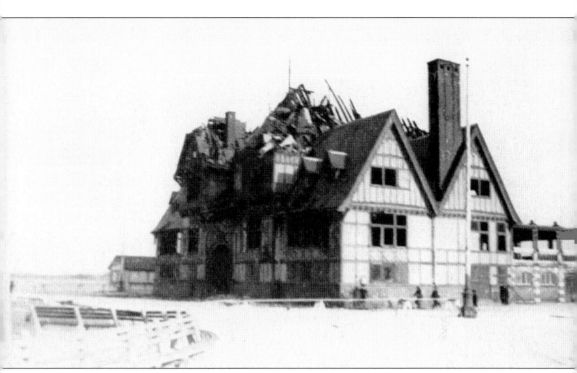

One would think, given the preceding collection of cards that show large gatherings congregating happily about the Head House and environs, that the two-alarm blaze that ravaged the lavish superstructure on December 5, 1942, would have been front-page news. However, this conflagration occurred only a week after the Cocoanut Grove holocaust, which resulted in 492 fatalities, the second-worst single-structure fire in American history. The demise of the Head House, therefore, garnered virtually no coverage in the local dailies. The sad truth is that the building had fallen into disrepair following the Hurricane of 1938 and had not even been open to the public during the summer of 1942. According to retired Boston fire commissioner Paul Christian, the call came in at 5:31 a.m., leading some to speculate that the fire may have been set. This was not the first time that the building had suffered fire damage, but expensive repairs were not a viable option in a wartime economy. Within weeks, the decision was made to raze the building, a sad end for the enchanting seaside landmark.

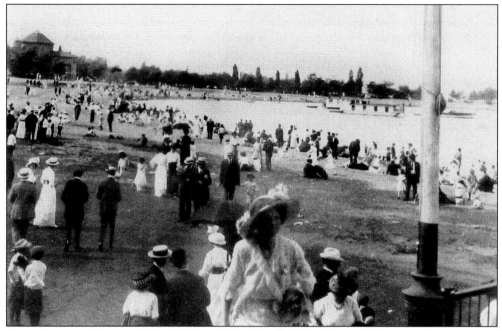

According to architectural historian Jean Holtz Kay, the Head House "fell prey to the poverty of twentieth-century urban life." Although the absence of the Head House and Kelley's Landing has left a void, Pleasure Bay maintains its allure to those who appreciate its natural beauty and serenity. (Above, courtesy of Steve Mulrey of Amrhein's; below, courtesy of Historic New England.)

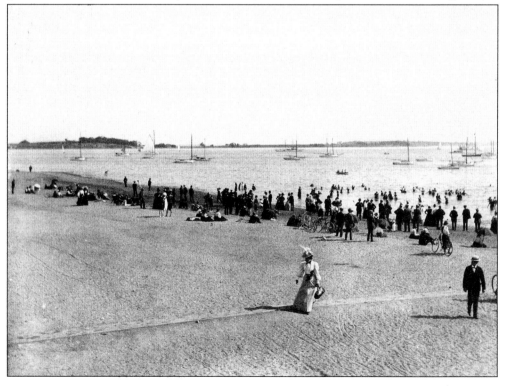

Two

MARINE PARK AND CASTLE ISLAND

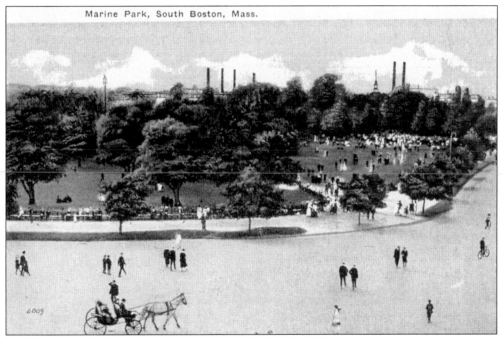

Marine Park, South Boston, Mass.

Inspired by the English system of parks and botanical gardens, landscape architect Frederick Law Olmsted sought to use nature to mollify the stressful influences of city living, "the symptoms of which are nervous tension, over-anxiety, hasteful disposition, impatience, [and] irritability." Marine Park was the final jewel in Olmsted's Emerald Necklace, the string of public parks and sylvan spaces created between 1878 and 1895. Comprising over 20,000 acres, it linked Boston Common and the Public Garden with the Fenway, continued to Jamaica Pond and Arnold Arboretum, then connected Franklin Park with Marine Park via Columbia Road and the Strandway. This *c.* 1915 postcard presents a rather unusual overhead view of Marine Park, the landscaping and grading of which were completed in 1890, looking north from the eastern end of the Strandway. As with several other cards in this section, the photographer's vantage point is one of the Head House's upper floors.

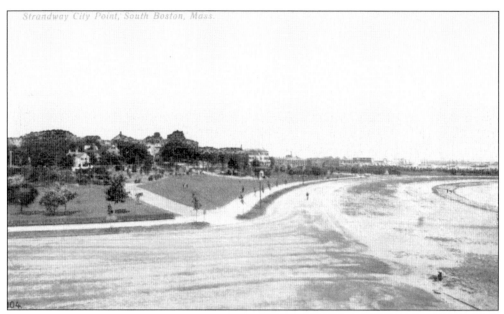

Plans were drawn up in 1889 for construction of a thoroughfare that would connect Marine Park to Columbia Road, the conduit to Franklin Park, a distance of about four miles. Numerous delays ensued, but the road, which adhered to the shoreline and converged with Columbia at Mount Vernon Street, was completed in 1895. Although still referred to by many as the Strandway, it was renamed William Day Boulevard on July 31, 1950, by an act of the state legislature to honor the memory of the widely admired jurist.

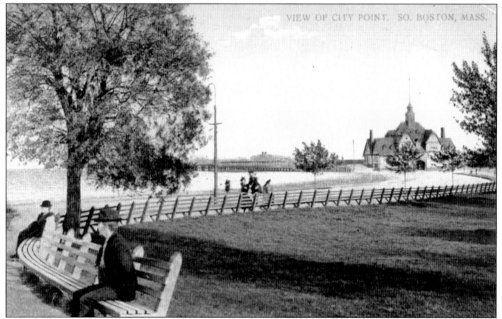

A row of benches, long since removed, rings the periphery of Marine Park in this postcard produced in Germany by Reichner Brothers and postmarked 1909. Several commercial enterprises, including a hotel and a restaurant, were forced to vacate the premises when the park was originally laid out. (Courtesy of Joe Williams.)

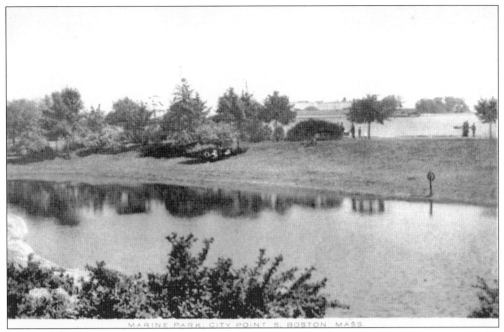

Designed by Frederick Law Olmsted in the 1880s, construction of Marine Park commenced in 1883. Seawater encroached upon the surface with the rising tide, so the brackish terrain was filled in, significantly enlarging the area of the park, then graded, landscaped, and contoured. Additionally, Q Street was widened to accommodate the anticipated increase in the number of visitors. Although the Aquarium would not be built until 1912, plans for its construction had been discussed for two decades. The area around the Aquarium, in which were to be housed "porpoises, seals, walruses and the like," was designed to incorporate three shallow ponds to enhance the museum's nautical setting. The ponds were completed in 1893.

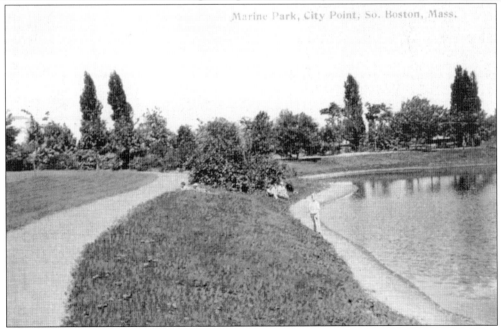

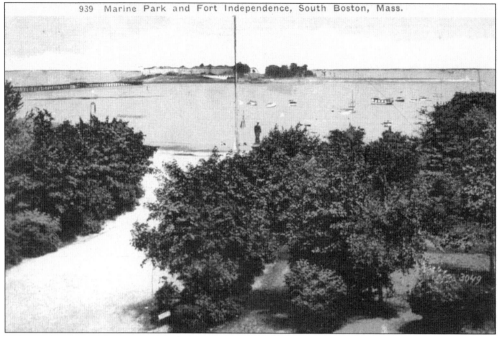

Castle Island was linked to Marine Park by the Castle Island bridge, visible here at left in the upper card, constructed in 1892. The photographer appears to have captured this view from a third-floor piazza or roof of one of the homes on Farragut Road. In the foreground, a canopy of dense foliage provides shade for park visitors. In the lower card, a trio of pedestrians is framed by the thicket of trees that lines the perimeter of the park. (Below, courtesy of Mike Ritz.)

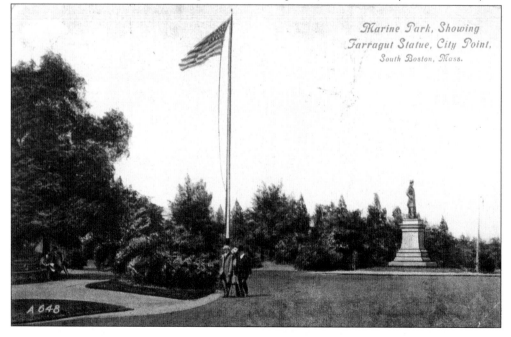

Marine Park, Showing Farragut Statue, City Point, South Boston, Mass.

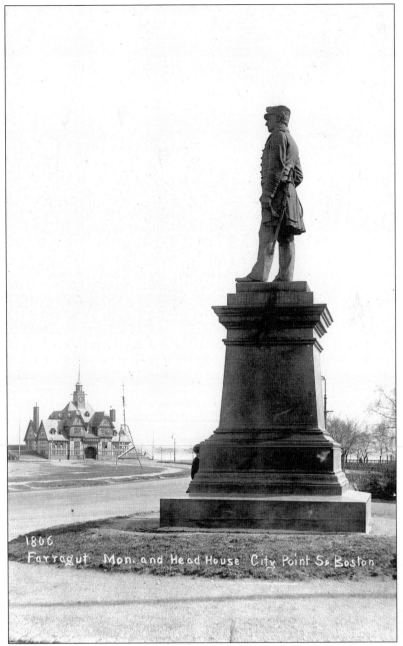

1806
Farragut Mon. and Head House City Point So. Boston

In the waning decades of the 19th century, numerous bronze monuments were erected to commemorate the contributions of Civil War heroes, including Ulysses S. Grant, William Tecumseh Sherman, Robert E. Lee, and many others. It was suggested that Marine Park, because of its coastal location, would be an appropriate site for a statue to honor Adm. David Glasgow Farragut, the Civil War naval hero. In 1889, a bill was submitted to the Boston City Council by councilmen Kelley and Keenan of Ward 8 to consider erecting a monument to the memory of Farragut. It was approved by aldermen and the mayor in 1890 and a committee appointed to oversee the project. Designs and models were solicited and sculptor Henry Hudson Kitson was selected to create the bronze likeness.

During the latter part of the 19th century, New England was home to some of America's most accomplished sculptors, including Irish-born Augustus Saint-Gaudens, Daniel Chester French, and Cyrus Dallin. Less well remembered than his contemporaries is Henry Hudson Kitson (1862–1941), who was awarded the commission to sculpt the Adm. David Glasgow Farragut statue. Born in Huddersfield, England, he emigrated to this country at 13 and found employment as a stone carver in the studio of his brother Samuel. He later studied sculpture at the École des Beaux-Arts in Paris. Eventually, he established an elaborate studio in the remote Massachusetts village of Tyringham and embarked on a career as a prolific sculptor of public monuments, many of them Civil War military leaders. His most recognized works are probably the *Lexington Minuteman*, Capt. John Parker, on Lexington Green and the *Indian Maiden* in Plymouth. In 1893, Kitson married a protégé, Brookline native Theo Alice Ruggles, who became an accomplished sculptor in her own right and the first woman admitted to the National Sculpture Society. In addition to the Tyringham studio, the creative couple maintained another home on Park Lane in Quincy. (Courtesy of the Vicksburg National Military Park.)

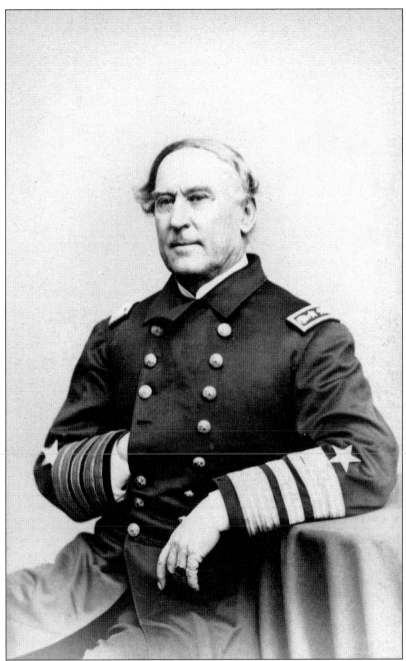

David Glasgow Farragut (July 5, 1801–August 14, 1870) was the highest-ranking naval officer of the American Civil War, the first man to hold the positions of rear admiral, vice admiral, and full admiral in the U.S. Navy. The son of a Tennessee militia cavalryman who served in the Revolutionary War, he enlisted as a midshipman at the age of 10 and demonstrated precocious nautical skill and leadership qualities. At 12, during the War of 1812, he was entrusted with the formidable task of bringing a captured ship to port. He rose quickly through the ranks and by the time of the Civil War had advanced to commander of the Union's West Gulf Blockading Squadron. (Courtesy of the Boston Public Library.)

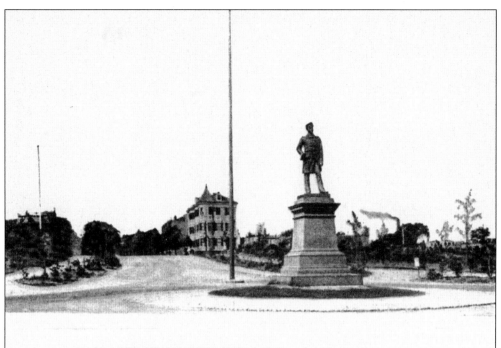

FARRAGUT MONUMENT, CITY POINT, SOUTHBOSTON, MASS.

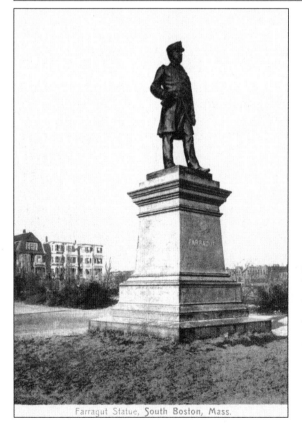

Farragut Statue, South Boston, Mass.

David Glasgow Farragut's forces captured the port of New Orleans in 1862 and Port Hudson in 1863. These victories left Mobile, Alabama, as the sole operating Southern port in the Gulf of Mexico, and it was here that Farragut would become a national hero. From his flagship, the USS *Hartford*, he led his fleet into Mobile Bay, which was heavily mined (tethered mines, in the parlance of the times, were called "torpedoes"). Undaunted, the implacable Farragut exclaimed, "Damn the torpedoes! Full speed ahead!" The Union armada took Mobile, effectively cutting off Confederate supply routes in the gulf and securing Farragut a venerable place in American history. He died at age 69 in Portsmouth, New Hampshire, and was interred at Woodlawn Cemetery in the Bronx, New York.

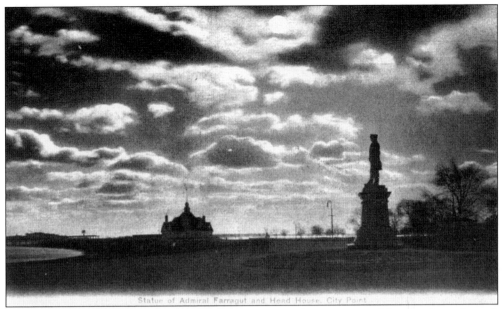

Statue of Admiral Farragut and Head House, City Point

The eight-foot-tall Farragut bronze was cast in France, and a ceremony celebrating the sculpture's unveiling at Marine Park was held on June 28, 1893. The day had been designated a holiday so that citizens of all ages could attend the unveiling, and the park was thronged with enthusiastic revelers. The celebratory proceedings included a spirited parade, after which Gov. Alexander Rice delivered a stirring oration and Annie Flood, daughter of Alderman Thomas W. Flood, drew the cord that unveiled the bronze likeness of Farragut. The triangular object to the right of the Head House in the lower photograph is an engineer's target for harbor dredging operations.

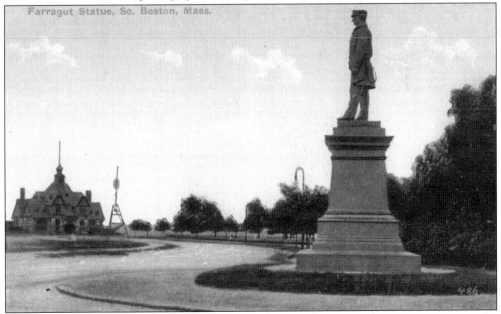

Farragut Statue, So. Boston, Mass.

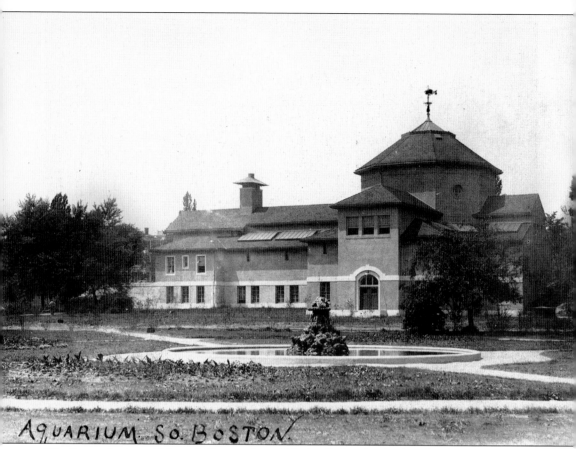

Aquarium So. Boston.

The Boston Society of Natural History selected Marine Park to be the site of an "aquarial garden," which would become known as the Aquarium. Although designs were prepared as early as 1889, construction would not commence for over two decades and was finally completed in 1912. Located in the park directly opposite the terminus of East Third Street, with the main entrance facing south, construction took more than a year and the opening, originally scheduled for June 17, had to be postponed several times. A newspaper account of the day reported that "for two months, half a dozen seals and sea lions have been in the pool and visitors who have seen them have been greatly amused by their antics, especially at feeding time in mid-afternoon." The Aquarium derived its supply of seawater from a 100,000-gallon underground reservoir located approximately 50 feet northeast of the building. It was filled with seawater transported in capacious tanks mounted on barges and pumped into the reservoir. This rare photograph provides a view of the park's fountain as well. (Courtesy of Mike Ritz.)

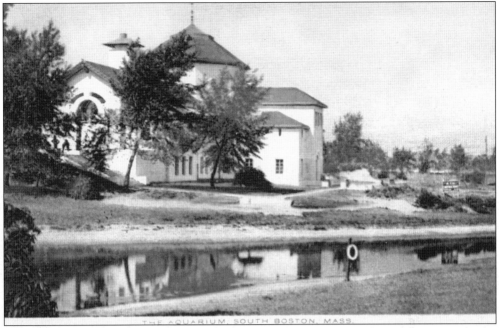

The Aquarium opened to the public on Thanksgiving Day 1912 and immediately became one of South Boston's most popular venues, attracting visitors from all over the city. Designed by architect William Downes Austin, the Aquarium could be readily identified by its stucco exterior, red-tile roof, and bronze cod weather vane. The structure's cavernous interior was lined with 55 fish tanks containing a wide variety of aquatic life, while mermaids cavorted on the pedimented, arched entranceway, enticing passersby to draw near. The upper postcard features still another view of the Aquarium, this from the rear, looking west toward Farragut Road.

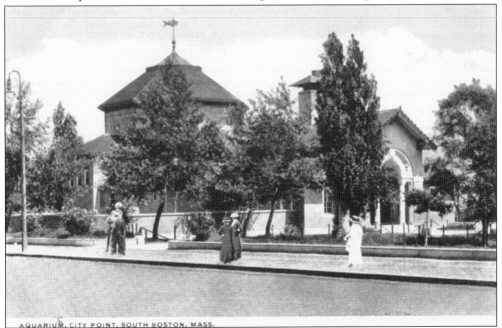

CITY POINT AQUARIUM HAS 15,030 VISITORS.

ts First Sunday, Attracting Both Adults and Childr
Proves It Is to Be at Once Popular.

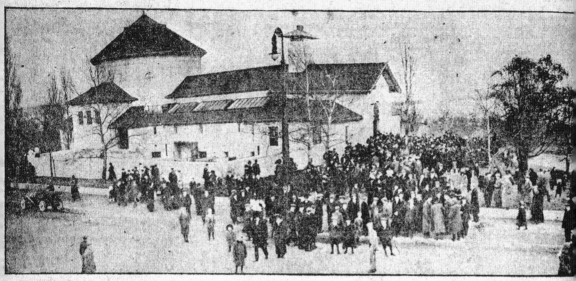

BOSTON'S NEW AQUARIUM, SHOWING THE SIZE OF THE CROWD WHICH SOUGHT ADMISSION ALL YESTERDAY AFTERNOO

Slightly more than 15,000 people visited e City Point Aquarium yesterday, the unt being 7315 for children and 7715 r adults.

Three times were Supt Mowbray and s assistants obliged to close the doors mporarily, so great was the crowd uring the afternoon, when there were ng lines of visitors waiting to enter. Auto parties were numerous, and at e time, in mid-afternoon, there were automobiles waiting on Farragut ad, their occupants visiting the aqua- um.

Yesterday was the first Sunday the public was admitted. It was an ideal Sunday, too, and all roads seemed to lead to Marine Park. Supt Clough put on several extra cars, and there was need of them, for big crowds were un- loaded at East Broadway and East 3d st, a block away from the aquarium.

From the opening time, 10 a m, until noon the South Boston people visited the aquarium in large numbers. After church the promenade parties made the aquarium their objective point, and this was an indication of what was to follow. Men, women and children, all in their Sunday best, were eager to get a glimpse inside of Boston's first aquarium, and the first ever estab- lished east of New York.

Once inside the building and there was much reason for the exclamations of surprise and admiration. Visitors en- tered by the small door on the right. Umbrellas (a few of them) and canes were checked near the main door and then the visitors passed along down the right section of the nave, first in- specting the 100 yellow perch and then the varied display of sunfish, and along past the several tanks, into the right transept and then around the big pool with its sportive quartet of sea lions and the big leopard seal.

There was no delaying along the way, the crowd was kept moving all the time, for there were others outside waiting to get in and the attendants

scattered through the building urged the people to keep movin be satisfied with a glance at the s tanks.

It was a big crowd and a well fied crowd. The children partie were astonished, for never befor they seen such a great varie strange and beautiful fellows in t family.

Saturday's crowd of visitors bered 4100, including a crowd of "hikers" or walkers who visite Aquarium as the concluding feat their walk through the Park Syste

During the Winter months the rium will be open from 10 a m p m, Sundays included.

The Aquarium was a sensation from opening day, as can be seen from this December 2, 1912, *Boston Globe* article. The reporter states that "three times were Supt. Mowbry and his assistants obliged to close the doors temporarily, so great was the crowd during the afternoon, when there were long lines of visitors waiting to enter." He further observed that "auto parties were numerous, and at one time, in mid-afternoon, there were 17 automobiles waiting on Farragut road, their occupants visiting the aquarium."

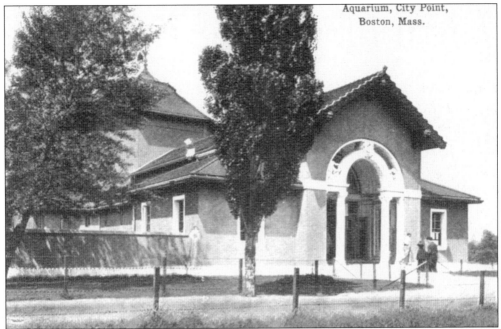

Although it remained a popular attraction for five decades, by the 1950s the building began to suffer from neglect. Patrons complained of poor maintenance and unpleasant odors. In 1956, the malodorous structure was closed down and finally fell to the wrecking ball in 1960. Removed before demolition, the famous cod weather vane was placed atop the canopy over the entrance to the new skating rink, from whence it mysteriously disappeared. The city was without an aquarium for a decade until the current version was erected on Rowes Wharf, off Atlantic Avenue, in 1969. (Courtesy of Joe Williams.)

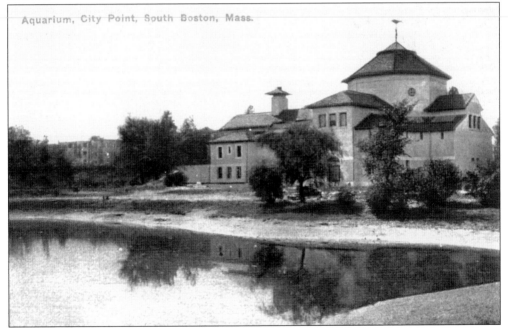

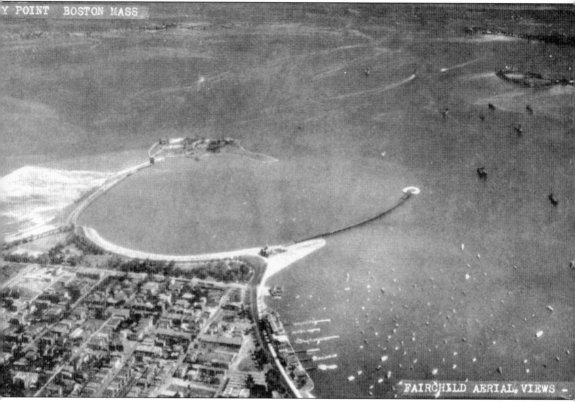

FAIRCHILD AERIAL VIEWS

Castle Island actually was an island at one time, though it was already connected to the mainland by the time this 1925 aerial photograph was taken. In 1892, the Castle Island bridge was constructed, linking the northeast section of Marine Park with the northwest tip of the island. The bridge was replaced by a footpath supported by solid fill in 1925 and a road for automobile traffic paved in 1932. The iron pier that projects from the rear of the Head House to its terminus at Head Island, or the "Sugar Bowl," was constructed in 1896. Clearly evident in this photograph is the opening to Pleasure Bay, which measured approximately 1,600 feet from the southern tip of the island to the Sugar Bowl. Pleasure Bay was not enclosed until the causeway that connected the two points, complete with locks to control the tides, was built in 1959.

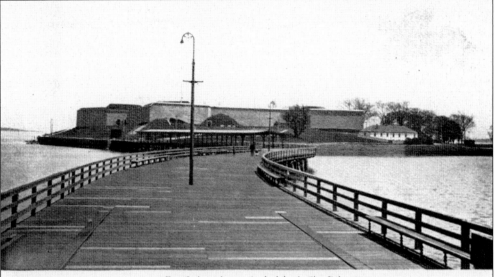

Fort Independence, Castle Island, City Point.

Frederick Law Olmsted had suggested building a causeway to connect Marine Park with Castle Island, as well as a pedestrian pier and a playground, but it would be years before his vision would come to fruition. The city owned Marine Park, but Castle Island was the property of the federal government until 1888, and although South Boston congressman Patrick Collins succeeded in passing a resolution permitting the city to build the causeway, it was vetoed by Pres. Grover Cleveland. In 1890, Congress passed legislation that ceded authority over Castle Island to the municipal government and allowed Boston taxpayers to erect a wooden bridge connecting the island with the mainland.

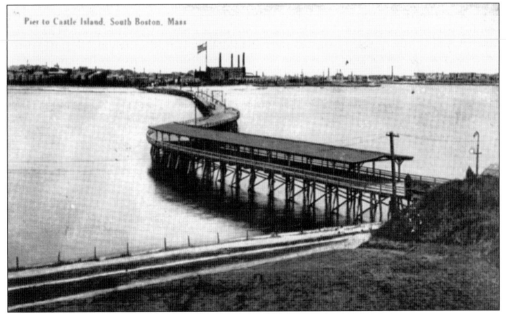

Pier to Castle Island, South Boston, Mass

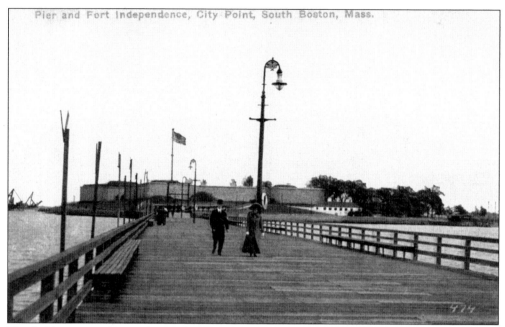

The bridge opened on July 29, 1892, and hundreds of residents availed themselves of the opportunity to walk to Castle Island for the first time. The bridge was constructed of wooden planks and electric arc lights were installed at regular intervals. Note the shadow in the foreground of the lower photograph. It appears that the photographer, with the setting sun behind him, has captured not only his own shadow but that of his tripod-mounted camera as well. Visible at right in both postcards is the white commandant's house, which burned on April 14, 1962. A favorite pastime of local youngsters was rolling down the small hillock to the left of the house, which was a magazine. It was leveled in 1964 when the landscape of the island was altered to prevent erosion of the hills.

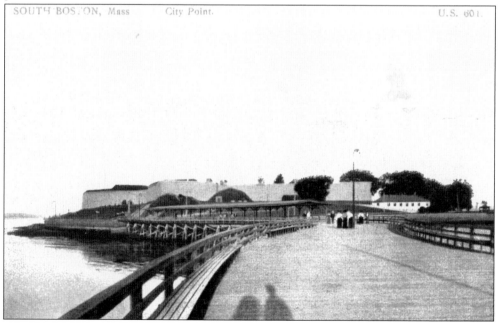

SOUTH BOSTON, Mass City Point. U.S. 601.

48

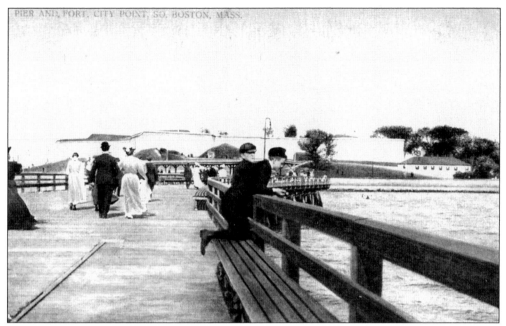

For over a century, nature lovers, fitness buffs, bicyclists, roller skaters, couples of all ages, and young aquaphiles have found Castle Island to be the ideal spot for exercise, recreation, meeting friends and neighbors, or just enjoying the great outdoors. In the lower card, which dates to about 1907, bicycle riding on the bridge was apparently prohibited judging from the number of people escorting their wheeled conveyances on foot.

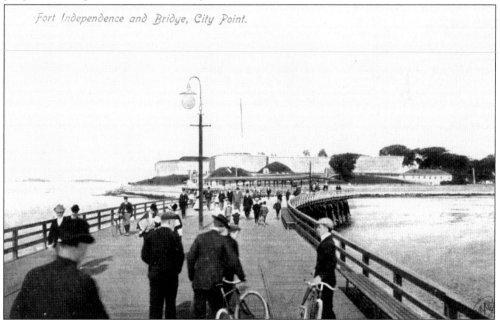

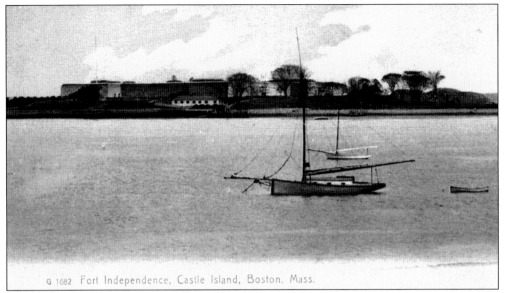

G 1682 Fort Independence, Castle Island, Boston, Mass.

Postcards of Fort Independence were produced in great abundance but tend to be quite similar, so only a few are pictured here. Initially known as Fort William, the fortifications at Castle Island predate the founding of the nation. Selected as a defensive site for the city in 1634 by Gov. Thomas Dudley, the original fort was modified by the British before it was relinquished to the colonists when British forces abandoned the city in 1776. In 1789, Massachusetts ceded authority over the island to the federal government and, in that same year, Pres. John Adams dedicated the structure as Fort Independence. The five bastion configuration was retained when the fort was subsequently reconstructed under the supervision of Gen. Sylvanus Thayer, "the Father of West Point."

Fort Independence, City Point, South Boston, Mass.

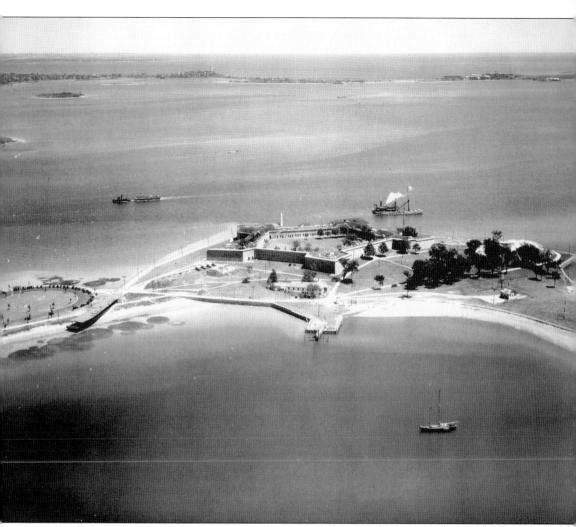

This spectacular 1936 photograph presents a sweeping aerial vista of Boston Harbor and the harmonic convergence of granite and greenery that is Castle Island. Aside from the familiar sidereal outline of Fort Independence, a great deal has changed in the interim. The dark object lying diagonally across the beach is the last vestige of the Castle Island bridge, its wooden roof still intact. The bridge and the rotary to its left, called Gleason Circle, were removed as part of the renovation of the island in 1964. The mudflats to the left of the bridge remnant have disappeared and the contours of Castle Island expanded as portions of the periphery were filled in. No longer extant are the gun emplacements adjacent to the fort's west and northeast walls and the commandant's home. The pier that protrudes into Pleasure Bay was the site of the raft capsizing that claimed the lives of four youngsters in 1896. The white building at right, partially obscured by trees, is the U.S. Army Signal Corps station. Just beneath the horizontal Winthrop Peninsula at upper left are Apple Island and Governor's Island, both of which were enveloped by extension of the mainland as part of the development of Logan Airport. The author's father recalls trekking across the frozen surface of the harbor from Castle Island to explore Fort Winthrop on Governor's Island on a particularly frigid winter day in the 1930s. (Courtesy of Paul Adamson via Bill Spain of the Castle Island Association.)

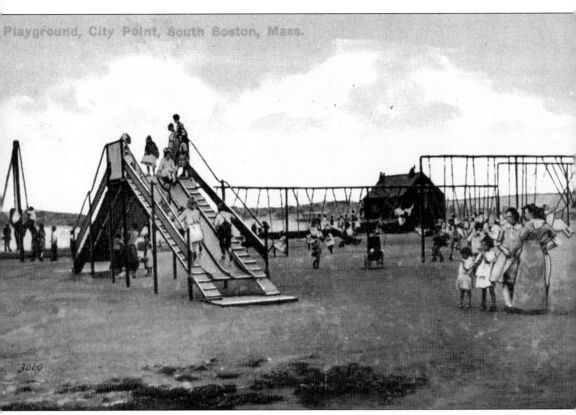

Playground, City Point, South Boston, Mass.

3060

Toward the close of the 19th century, social reformers argued strenuously for the funding of new playgrounds, ball fields, and other outdoor recreational activities in an effort to guide young people away from the unsavory temptations of pool halls and gin mills. Municipal appropriations for parks and playgrounds increased dramatically throughout the 1890s, and the City of Boston maintained 40 playgrounds by 1915. The location of the playground pictured here is difficult to pinpoint with absolute certainty; an educated guess would be Castle Island.

Three

Yacht Clubs and the L Street Bathhouse

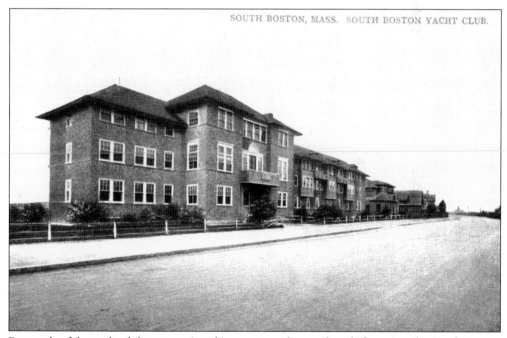

SOUTH BOSTON, MASS. SOUTH BOSTON YACHT CLUB.

Postcards of the yacht clubs were printed in great number, and cards featuring the South Boston Yacht Club are most numerous. The original club was situated at the foot of K Street and was dedicated on July 15, 1868, but membership soon outgrew this modest structure, and in 1877, a new building was erected on East Sixth Street near the intersection of P Street. The club was formally incorporated according to Massachusetts statutes "for the purpose of encouraging yacht building and natural science" on April 2, 1877, and claims the distinction of being the oldest chartered yacht club in America. Within a decade, it would boast 152 members and 44 yachts. However, the building obstructed the extension of the Strandway, and in 1899, members were obliged to pull up stakes yet again and move to the current location on the water side of Columbia Road.

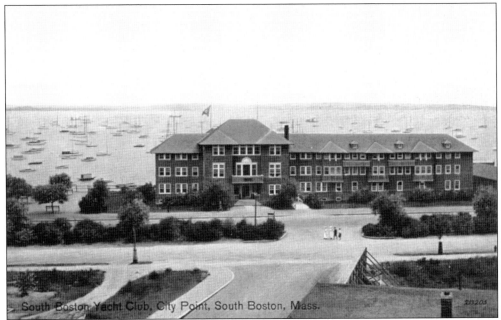

South Boston Yacht Club, City Point, South Boston, Mass.

In his book *The Illustrated History of South Boston*, published in 1900, author C. Bancroft Gillespie may have engaged in just a bit of hyperbole when he described City Point as "the greatest yachting center in the world." Even so, boating, swimming, and other aquatic pursuits were extremely popular activities at the beginning of the 20th century. In describing the range of craft to be found in the harbor, John J. Toomey and Edward P. B. Rankin observed, "In its variety, the fleet includes almost every style of boat used for pleasure, from the little naptha launch to the handsome sloop yachts and schooners of a considerable size, making the fleet unequalled in number on the Atlantic seaboard and unequalled in value except by the fleet at Newport, Rhode Island."

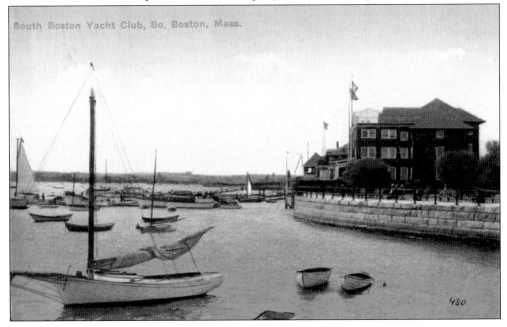

South Boston Yacht Club, So. Boston, Mass.

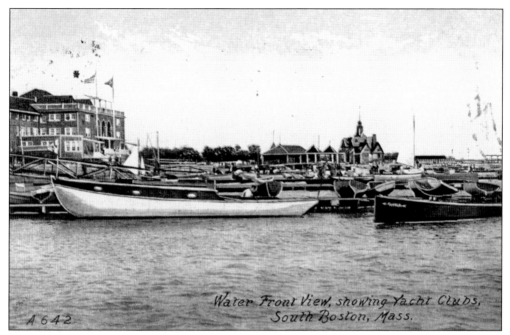

Water Front View, showing Yacht Clubs, South Boston, Mass.

A 642

The current version of the South Boston Yacht Club was designed by the architectural firm of Maginnes, Walsh and Sullivan, built in 1899 at a cost of $19,000, and featured an expansive reading room, an elegant ladies' reception room, spacious corridors and storage facilities, and a rock garden. By 1901, membership swelled to 350 with over 150 yachts, and a new wing was added, comprising a billiard room, bowling alleys, library, and lounge.

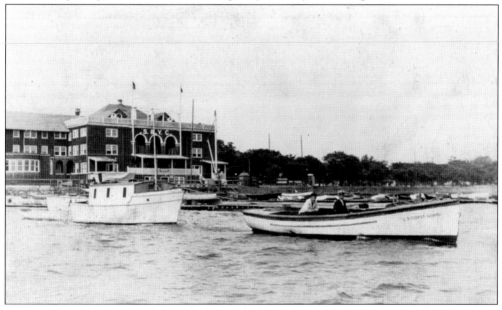

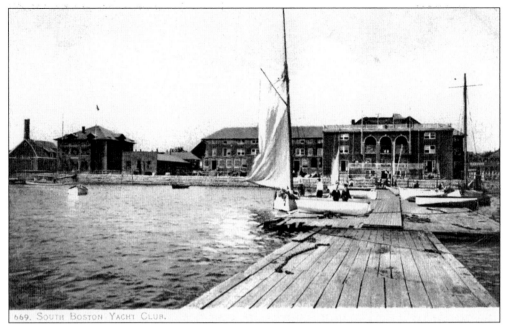

669. SOUTH BOSTON YACHT CLUB.

The Columbia Yacht Club, pictured in the lower card, was founded in 1896 and assumed ownership of the wooden structure at the foot of P Street that had been previously occupied by the Commonwealth Yacht Club. Shortly thereafter, club members were informed that their building was an impediment to the extension of the Strandway to Q Street. Bonds were issued and in September 1899, the structure pictured in these postcards was completed. The new edifice offered patrons a circular reception room and staircase hall, spacious recreation room, a 34-by-30-foot dance hall, and three tiers of verandas with unobstructed views of the harbor.

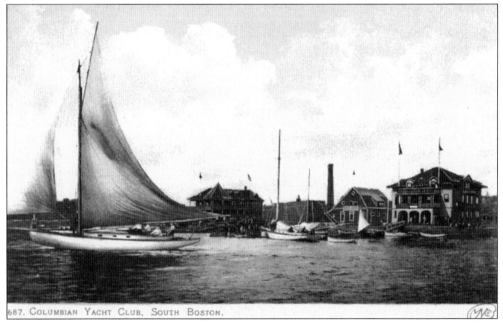

687. COLUMBIAN YACHT CLUB, SOUTH BOSTON.

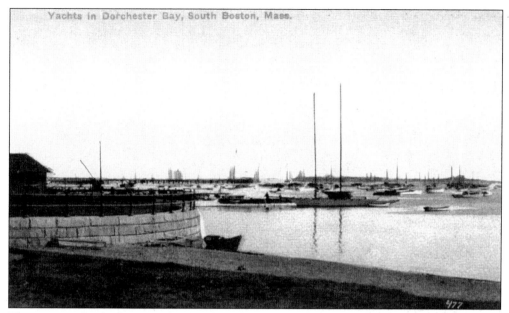

Yachts in Dorchester Bay, South Boston, Mass.

The water surface looks quite placid in the top card, but there is an incident on record of a violent intrusion by a predator from the depths. In 1936, a great white shark attacked a 16-year-old boy in Dorchester Bay. Fortunately, the assault was not fatal. The lower card reveals yet another benefit of yacht club membership—off-street parking. It is possible to approximate the years in which these postcards were produced, even when they are not postmarked, from their designs. The upper card has no border, indicating that it was printed between 1907 and 1914. From 1915 to 1930, postcard publishers left white borders around the edges of cards as a cost saving device since this practice required less ink. The bottom card, then, can be assigned to this era.

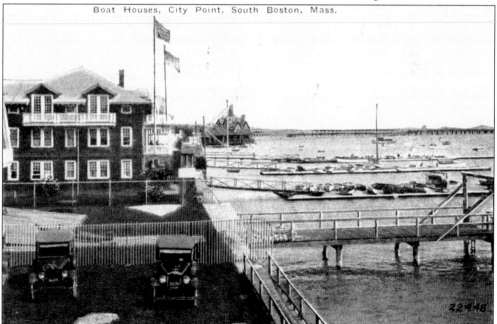

Boat Houses, City Point, South Boston, Mass.

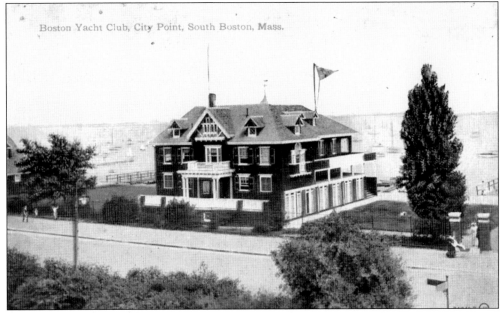

The yacht clubs appealed to boating enthusiasts of varied interests. The South Boston Yacht Club, for example, was renowned for developing sailboat racing champions. The smallest club, the Columbia Yacht Club, typically attracted members from the business community, while the Boston Yacht Club enrollment tended to be more affluent. The activities of these clubs were of great interest locally, and results of regattas, races, and changes in administrative officers were faithfully reported by the *Boston Post, Globe, Herald, Transcript,* and other daily newspapers. Each of these postcards portrays the Boston Yacht Club during the first decade of the 20th century.

Boulevard, Marine Park, City Point, South Boston, Mass.

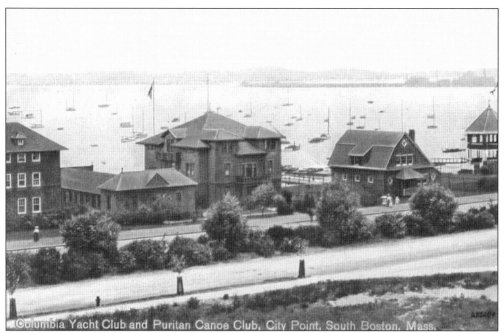

Sandwiched between the yacht clubs was the Puritan Canoe Club, formed in 1887, though the structure pictured here was erected in May 1899. Considerably smaller than the yacht clubs, it was nonetheless a comfortable facility with the lower floors used for the storage of canoes of all types and a locker room. The upper floor included a large function room. Note that in the lower postcard, the Puritan Canoe Club is incorrectly labeled "Mosquito Yacht Club."

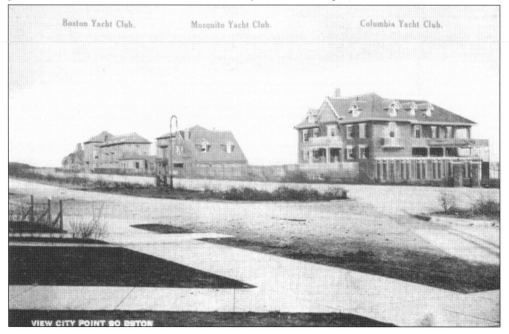

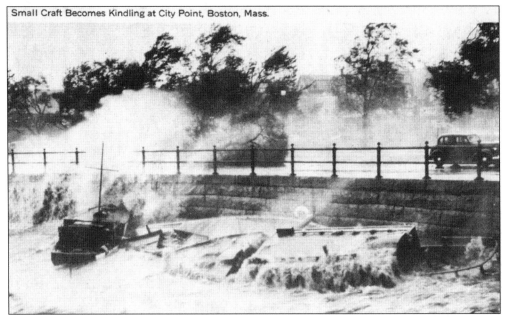
Small Craft Becomes Kindling at City Point, Boston, Mass.

One of the worst natural disasters in American history was the hurricane of September 31, 1938, a storm of immense fury and power that eclipsed every local record for wind speed, tidal surge, and barometric pressure. Although the storm vented the brunt of its destructive force on Long Island, Rhode Island, and Connecticut, Massachusetts was not spared its wrath. It left more than 600 dead (398 in Rhode Island alone, 99 in Massachusetts), 3,500 injured, 7,500 homes damaged or destroyed, 20,000 automobiles destroyed, and 3,000 boats sunk—an estimated $300 million property damage in Depression-era dollars, about $6 billion in 2004 dollars. Compare the aforementioned figures with the blizzard of 1978, which resulted in 54 fatalities, 29 in Massachusetts, and property damage totaling $1.3 billion. The practice of naming tropical storms, such as Katrina, Andrew, and Hugo, was not adopted by the National Weather Service until 1953; thus, this calamitous storm will ever be known as the Hurricane of 1938.

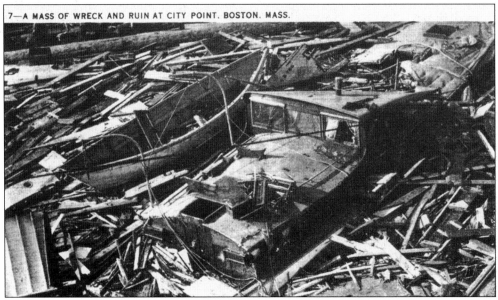
7—A MASS OF WRECK AND RUIN AT CITY POINT. BOSTON. MASS.

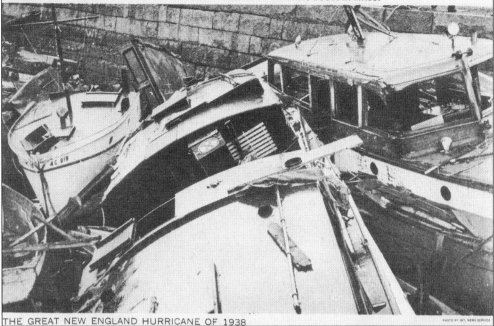

8—ALL THAT REMAINS OF BEAUTIFUL PLEASURE CRAFT, CITY POINT, BOSTON, MASS.

THE GREAT NEW ENGLAND HURRICANE OF 1938

One reason for the extensive devastation is the fact that the storm predated the use of weather satellites and other modern forecasting innovations, so New Englanders were unprepared for the watery onslaught. Boats were left on their moorings, and when monsoonlike torrents of rain propelled by 150-mile-per-hour wind gusts battered the coast for several days, thousands of small craft washed up on the beach. The author's father, who was then a freshman at Boston Latin School, recalls combing the beaches the following day hoping to find an intact vessel but finding virtually nothing salvageable.

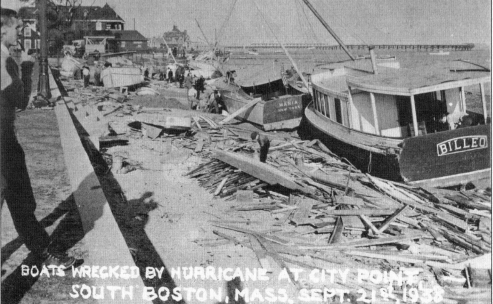

BOATS WRECKED BY HURRICANE AT CITY POINT SOUTH BOSTON, MASS. SEPT. 21st, 1938

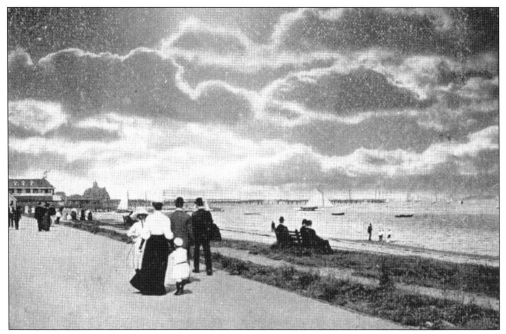

The artists employed by postcard publishers were adept at transforming diurnal views into matutinal or evening settings by skillfully rendering a morning sun or moonlit clouds. In the upper postcard, shadows cast by pedestrians would seem to indicate the sun in position almost directly overhead, yet the artist has inserted a rising sun and silhouetted cumulostratus clouds. In the lower photograph, bright color has been added to the windows of the various structures, as well as a brilliant lunar orb and backlit clouds to create an eerie nocturnal vista.

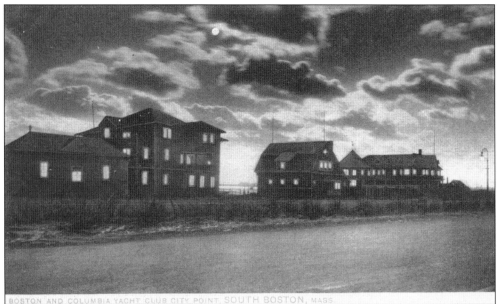

BOSTON AND COLUMBIA YACHT CLUB CITY POINT SOUTH BOSTON, MASS.

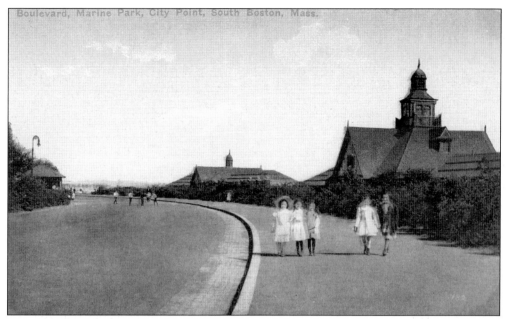

Boston's Yankee aristocrats were of the unshakable opinion that moral rectitude and corporal purity were inextricably linked. In the years following the Irish potato famine, the city was inundated with impoverished immigrants, many of whom lived in cold-water flats, and city fathers expressed grave concerns about these hygienically challenged newcomers. Six bathhouses were erected at different locales throughout the city, including L Street, where laborers could avail themselves of the opportunity to take a hot shower and rent a towel for one penny. Owing to its proximity to the Lower End, the Dover Street bathhouse initially surpassed the L in patronage, but the latter would become so heavily attended that in the spring of 1901 a new building was erected. The wooden edifice depicted in these *c.* 1908 postcards is the predecessor of the current brick structure, which was erected in 1931.

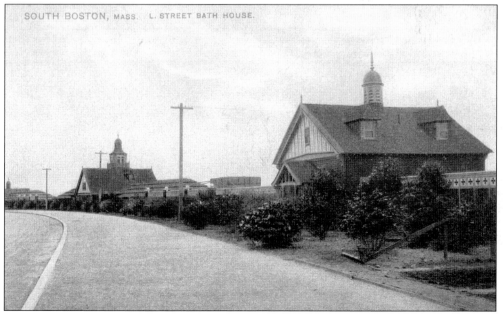

SOUTH BOSTON, MASS. L. STREET BATH HOUSE.

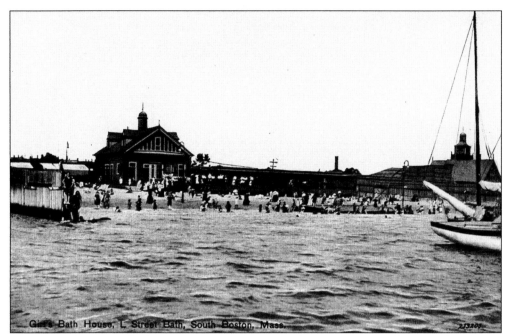

Girl's Bath House, L Street Bath, South Boston, Mass.

The original L Street facility was open to patrons in the three hours before and three hours after high tide, the only interval during which the beach could be used. Such was not the case with the new bathhouse, which adopted more conventional hours. Gradually, as living conditions improved and swimming became a more popular activity, the L evolved into more of a recreational facility and was frequently the site of rowing and swimming competitions. Moreover, because sunbathers went nude or wore the bare minimum, tall fences were installed that extended into the bay, separating the beach into men's and women's sections. The upper card here shows women relaxing and enjoying the beach while the lower card depicts the front entrance from the Strandway.

Mosquito Fleet Yacht Club, City Point, South Boston, Mass.

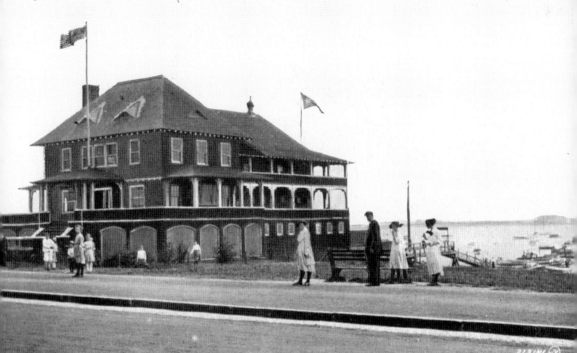

Strollers pause in front of the Mosquito Fleet Yacht Club, erected in 1889 on the beach just west of K Street. In 1897, the structure was moved down the beach a short distance in order to comply with directives of the park commissioners and the building was expanded and remodeled. It was described as being "three stories high, with commodious verandas on all sides, with billiard and pool, lounging and reception rooms, besides a large dance hall, bowling alley and magnificent locker facilities." The Old Harbor waters also provided abundant anchorage for yacht owners. By 1900, the club claimed some 300 members.

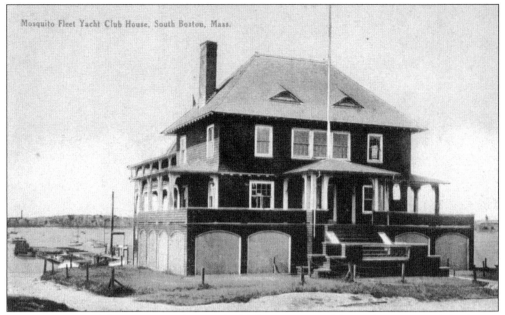

Mosquito Fleet Yacht Club House, South Boston, Mass.

Opposite views of the Mosquito Fleet Yacht Club are presented here, the upper card displaying the front while the lower card, as seen from the south, depicts the rear of the club as well as homes on Columbia Road. Trouble arose in 1931 when the city decided to rebuild and expand the L Street Bathhouse laterally to K Street. The women's wing extended to within 15 feet of the piazza where male members, some of whom may have been overserved, often congregated. The prospect of lascivious men leering at nubile female flesh was deemed unacceptable by those in positions of authority and the club was ordered to move forthwith. When the search for another site proved unsuccessful, officers reluctantly voted to disband, resolving to meet annually at a memorial dinner to ruminate about days gone by. The building was removed from the landscape in 1932.

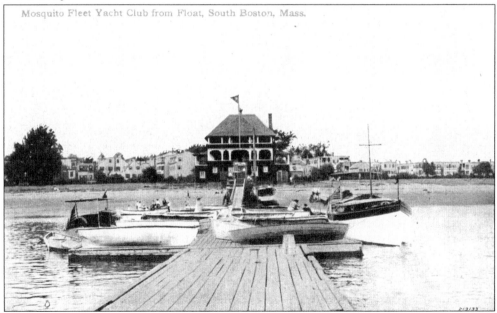

Mosquito Fleet Yacht Club from Float, South Boston, Mass.

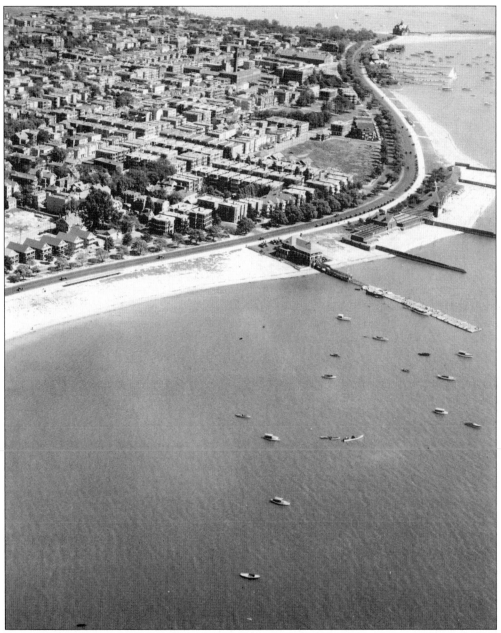

Some postcard collectors mistakenly assume that the Mosquito Fleet Yacht Club was located somewhere in the vicinity of the other clubs. It was, in fact, situated several blocks west, on the other side of the L Street Bathhouse, as this 1925 aerial photograph demonstrates. All the coastal landmarks are visible here—the Mosquito Fleet Yacht Club, L Street Bathhouse, the other yacht clubs, and the Head House. Note the absence of dwellings on Columbia Road between L and M Streets; the noisome stench that emanated from mudflats across the street proved an effective deterrent to home building on this block until the late 1920s, when the flats were filled in. (Courtesy of Paul Christian, Boston Public Library.)

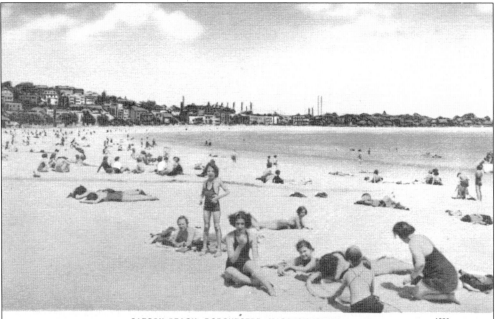

CARSON BEACH, DORCHESTER, MASSACHUSETTS 1086

These Carson Beach postcards were printed a couple of decades later than most of the preceding cards, the lower card bearing a postmark of 1943. On both, Carson Beach's location is erroneously identified as Dorchester, when, in fact, it has always been part of South Boston. The beach received its name in the early years of the 20th century when the city staged a contest between teams of swimmers from Carson and Mosely Streets in Dorchester, with the tract of sand to be named after the street of the winning team. The Carson Street swimmers emerged triumphant. For a brief period, however, between 1912 and 1923, the name was changed to McKenzie Beach, though it eventually reverted to Carson Beach. Documents identifying the namesake of McKenzie Beach have proven elusive, as has an explanation for selecting swimmers from two streets in Dorchester to name a beach located in South Boston.

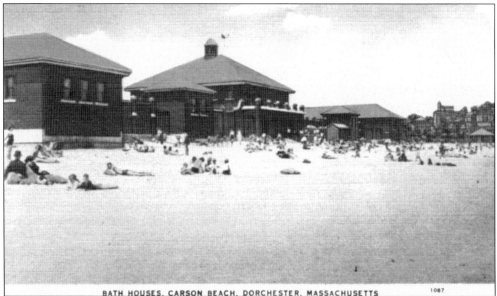

BATH HOUSES, CARSON BEACH, DORCHESTER, MASSACHUSETTS 1087

Four

CITY POINT

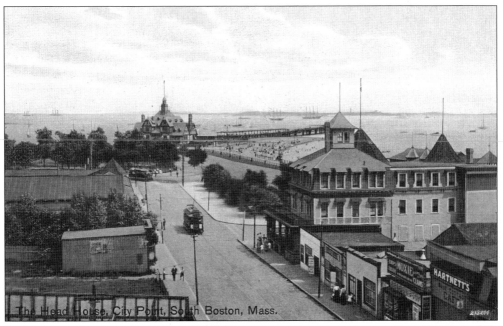

The Head House, City Point, South Boston, Mass.

In this postcard, postmarked August 27, 1908, a streetcar negotiates the turn from Q Street while another proceeds down East Sixth Street. At right is the Peninsula Hotel, the largest hotel in the district, at 855 East Sixth Street, while at the bottom right Hartnett's Wave Cottage can be seen. The photographer probably snapped this photograph from the roof or upper floor of one of the homes near the corner of P Street. Note the three-masted schooners that dot the horizon. The Wave Cottage was owned by John J. (Jack) Hartnett, a native of Tournafulla, County Limerick, and resident of 132–134 P Street, until passage of the Volstead Act persuaded him to close the establishment in 1918. The building was destroyed by fire in 1923. The Peninsula Hotel (formerly the Seaside House), run by James P. McShane of 18 Charles Street, Boston, was a successful enterprise until 1920.

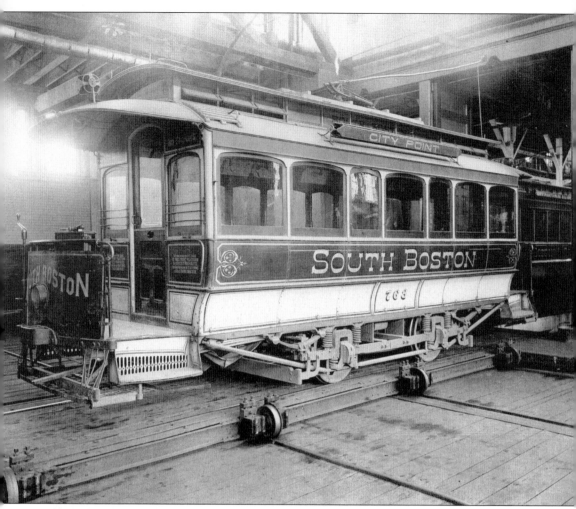

The predecessor of the Massachusetts Bay Transit Authority (MBTA) and Massachusetts Transportation Authority (MTA) was the Boston Elevated Railway, prior to which small, autonomous rail companies such as the West End Railway and the Bay State Line operated in the city. This photograph depicts splice car (so called because it was constructed by fusing together sections of two horse-drawn carriages) No. 763 at rest on the transfer table at the West End Railway's North Point Car House, which was located at P and East Second Streets. The number assigned indicates that it is a closed, rather than open, vehicle. Built in 1892 by the Ellis Car Company, the vehicle was powered by two 15-horsepower waterproof motors manufactured by Thomson Houston (now General Electric) and staffed by a motorman and conductor. Cruising speed was about 25 mile per hour and 30–32 passengers could be comfortably seated, although as many as 60 might squeeze on at rush hour. Trolleys of this type served Bostonians until about 1920.

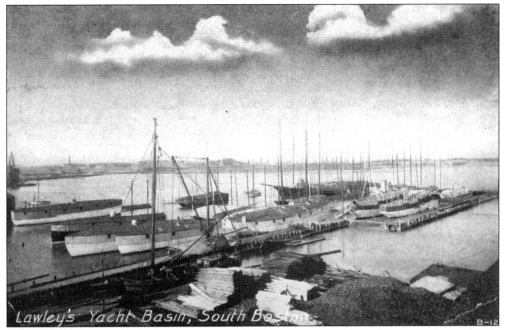

Lawley's Yacht Basin, South Boston

Lawley's Boat Basin was established in Scituate in 1866 by George Lawley, an Englishman who had previously worked for the estimable East Boston ship designer Donald McKay. The firm moved to South Boston in 1874, near the corner of P Street and Columbia Road, where a fully equipped facility for building yachts and boats was installed. Some of the finest sailing vessels in the nation, including America's Cup racers, were built here. As the business continued to expand, requiring additional space, Lawley moved the boatyard to the north side of City Point, near O Street, to acreage previously occupied by the house of correction. In 1910, the firm moved again, this time to Port Norfolk in Dorchester, where it continued to operate until after World War II.

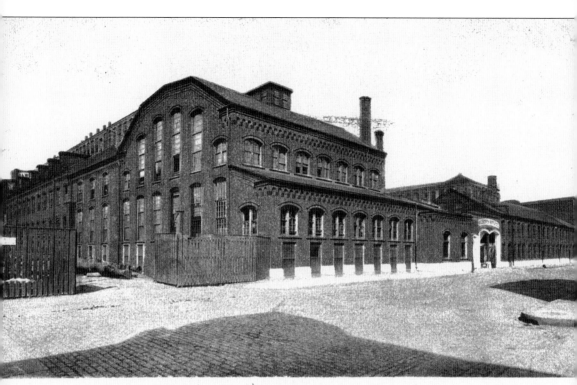

Walworth Manufacturing Company Building, South Boston, Mass.

Founded in New York in 1842 by James Jones Walworth, the Walworth Manufacturing Company was a sprawling industrial facility that produced a wide variety of high-quality industrial hardware: pipes, fittings, radiators, sprinklers, tools (including the Stillson wrench, which was designed by a Walworth employee, Daniel C. Stillson), die plates, steam pumps, gas generators, and a line of steel and brass valves. Moreover, the firm was a pioneer in the implementation of progressive labor practices, including the eight-hour workday, the half workday on Saturday, the hiring of women to work as secretaries, and the application of new technology, such as the telephone. So successful was this firm, which employed 1,300 workers, that in addition to its main office on O and First Streets, it maintained sales offices on High Street in Boston, New York City, Chicago, and other major cities. Walworth moved from South Boston in the mid-1950s and relocated to Texas, where it is a successful manufacturer of valves for industrial equipment to this day. The buildings along East First Street, pictured here, were demolished in 1958.

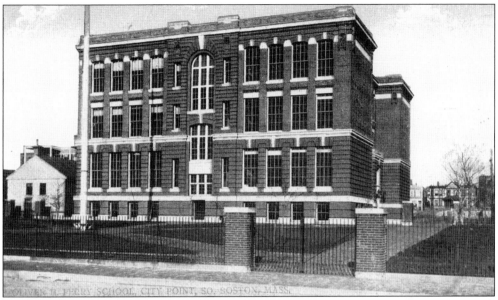

Built in 1904, the 14-room Perry School was named after the naval officer who defeated a British squadron at the Battle of Lake Erie during the War of 1812 and became a national hero at 28, Commodore Oliver Hazard Perry. When his flagship, the *Lawrence*, sustained heavy damage, Perry took command of another ship, the *Niagra*, and led a successful assault on the enemy force. After his stunning victory, Perry succinctly reported, "We have met the enemy and they are ours," a phrase that entered American folklore.

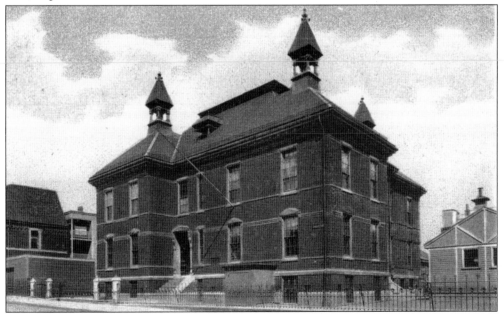

The eponymous Benjamin Pope Primary School was named to honor the memory of a successful lumber merchant and alderman. The two-story, eight-room structure was erected in 1883 at the corner of O and Fifth Streets, and children of City Point were educated here until 1946, when the building was sold to South Boston Council No. 78 of the Knights of Columbus. Today it is a condominium complex.

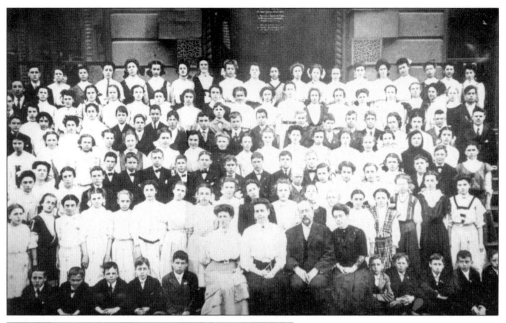

Depicted in the photograph is the graduating class of 1908 of the Oliver Hazard Perry School, though the setting of this picture is certainly not the Perry. The dark-haired boy in the center of the lower photograph is Richard James Cushing of 44 O Street, who would later become archbishop of Boston. After graduating from Perry, he matriculated at South Boston High School, where, if his transcript is any indication, academics were not a priority for the future prelate. He spent one year at Southie High and then transferred to Boston College High School, a pattern that would be duplicated by future Senate president William Bulger four and a half decades later. (Courtesy of Bob Healey.)

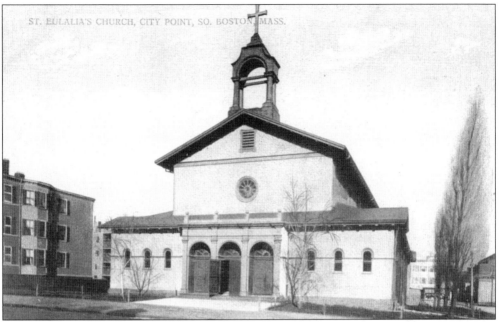

There was a residual but ever-diminishing Protestant population in the City Point area during the mid- to late 19th century. As the number of Catholic families increased, St. Eulalia's Church was erected at the corner of O Street and East Broadway on the lot currently occupied by St. Brigid's School and was dedicated on May 6, 1900. Originally a chapel of Gate of Heaven, it became a separate parish in 1908. Regrettably it was destroyed by fire on February 10, 1933.

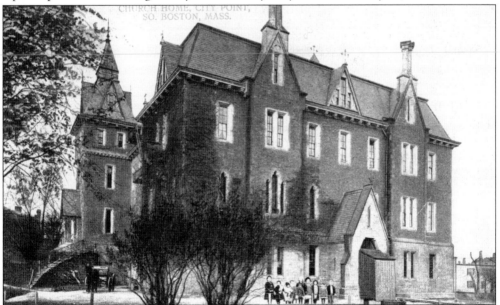

The Episcopal Church Home moved to the peninsula district in 1864, to the corner of East Broadway and N Street, where St. Brigid's rectory now stands. Here orphans and homeless children were provided with a "spacious, airy and healthy" domicile and enrolled in local public schools. The archdiocese purchased the building from the Episcopalian Church in 1912 and established the Nazareth Grammar and High School. The structure was demolished in 1966.

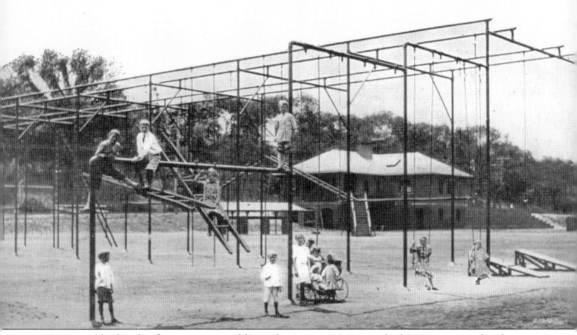

Pressured by local reform groups, public and private entities worked in concert to develop one of the most comprehensive playground systems in the country. In 1901, city administrators allocated $9,100 for construction of an outdoor gymnasium at the M Street Playground. This anachronistic contraption represented the state of the art in playground design at the beginning of the 20th century. By 1915, the City of Boston maintained about 40 playgrounds in various parts of town. During the 1920s, erstwhile New England League hurler-turned-entrepreneur Bill "Twilight" Kelly promoted semiprofessional baseball games at the park on weekend afternoons, despite the piles of anthracite in the coal yards adjacent to the field. In 1921, it was renamed the Christopher J. Lee Playground in remembrance of the courageous soldier from 25 Hancock Street in Dorchester who was mortally wounded in France and posthumously awarded the Distinguished Service Cross.

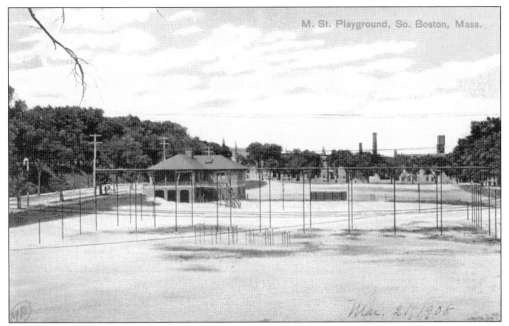

For the first two decades of the 20th century, M Street Park was bisected by East Second Street, which connected M and N Streets and separated the playground from Independence Square. The upper card presents another view of the playground and swing set with East First Street running diagonally on the left. Independence Square sports a more arboreal look in the bottom card, with rows of trees lining the park's intersecting footpaths.

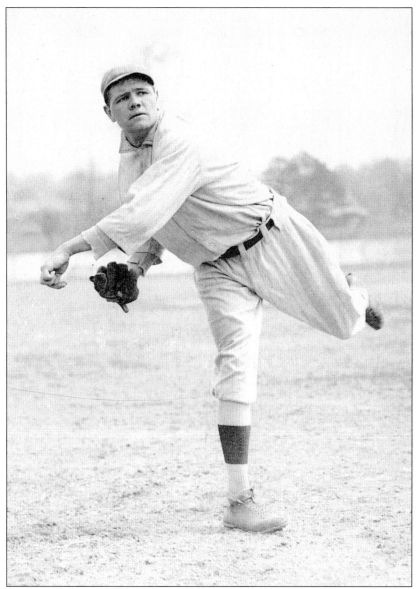

George Herman "Babe" Ruth, by any objective standard the greatest ballplayer that ever donned spikes, was a member of the Pere Marquette Council of the Knights of Columbus on N Street. He not only socialized in Southie but married a young woman named Helen Woodford from Silver Street. This picture, taken during spring training in 1915, is reported to be the earliest-known photograph of Ruth in a Red Sox uniform and brought $7,500 at auction in 2006. With Boston, Ruth would become the best left-handed pitcher in the American League. When his slugging skill merited his conversion to an outfielder, Ruth made the home run an electrifying spectacle and refashioned the game in his own image. Although some of his records have been eclipsed, consider the following little-known fact: until 1931, a ball that was hit out of the ballpark fair but then curved foul was ruled a foul ball; under modern rules, it would be a home run. Sports historian/empiricist Bill Jenkinson estimates that under today's rules, and in today's smaller ballparks, Ruth would have walloped over 1,000 home runs in his career. (Courtesy of Robert Lifson of Robert Edward Auctions.)

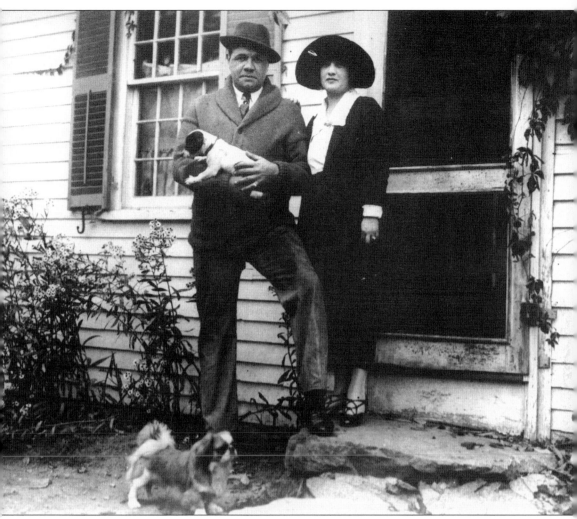

The Babe played minor-league ball in Providence and joined the Red Sox in 1914, taking a room at Josephine Lindberg's boardinghouse at 3 Batavia Street (now Symphony Road) before moving to the Putnam Hotel in Copley Square. Soon after his arrival, he took a liking to a young waitress named Helen Woodford who worked in Lander's Coffee Shop on Huntington Avenue. Her family was originally from Meredith, New Hampshire, but moved to South Boston in 1907, residing at 290 Silver Street and 5 National Street before settling down on West Fourth Street. About 30 years ago, the author painted several houses on Fourth Street, including the home of lifelong resident Dick Doyle, then in his 70s. He spoke of the crowds of onlookers that would gather to catch a glimpse of the star southpaw when he would arrive in his roadster to pick up his future bride. The couple married in 1914 and moved to a farm in Sudbury (pictured here), but the libidinous Babe was ill suited for monogamy and the marriage was a troubled one. They separated in the 1920s, and Helen died in a fire in Watertown in 1929. Coincidentally, her family's home at 420 West Fourth was destroyed by fire in 1945. (Courtesy of the National Baseball Hall of Fame Library.)

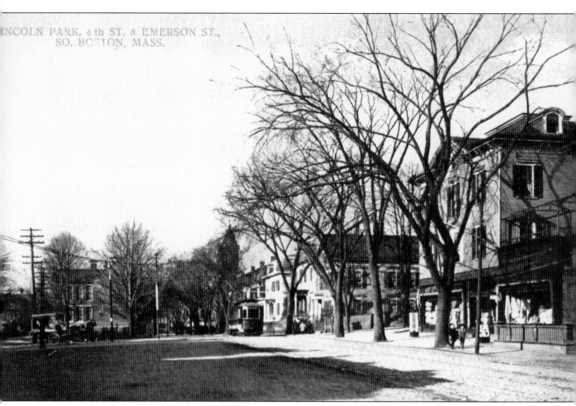

INCOLN PARK, 4 th ST. & EMERSON ST.,
SO. BOSTON, MASS.

Lincoln Park is the fenced-in, 9,510-square-foot triangular area at the junction of M Street, East Fourth Street, and Emerson Street, adjacent to the Tuckerman School. It was laid out in 1898, a few years before the Tuckerman was built. This card shows a streetcar proceeding down East Fourth Street while the horse-drawn cart at left ambles up M Street. The building at right was occupied by James H. Corney, one of the neighborhood's most successful purveyors of dry goods; today it is the home of Emerson Cleaners.

The original Tuckerman School opened in 1850 and expanded to six rooms in 1865. It was named after the Reverend Joseph Tuckerman, a member of the Primary School Committee from 1827 to 1828. The current, more expansive structure dates to 1906 and was active until 1981. It was subsequently sold and reincarnated as a condominium complex.

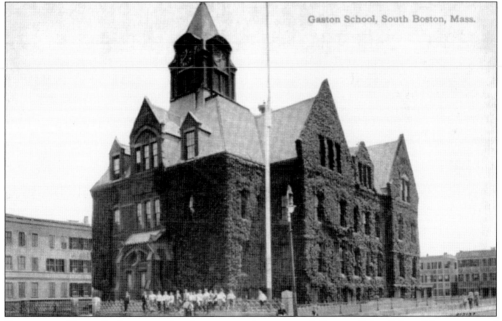

Gaston School, South Boston, Mass.

Surmounted by a clock tower, the three-story, ivy-covered Gaston School for girls was one of the most architecturally impressive buildings in the district. Located on East Fifth Street at the corner of L Street, it was constructed in 1873 and named after William Gaston, who was at that time mayor of Boston. The school served the community until 1972 and was demolished several years later.

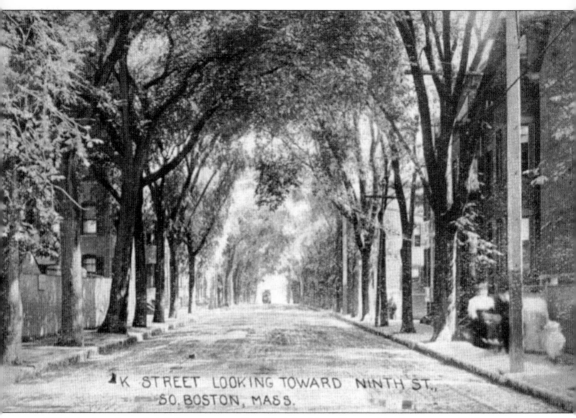

K STREET LOOKING TOWARD NINTH ST., SO. BOSTON, MASS.

With its bowfront brick homes, tree-lined brick sidewalks, and leafy canopy, K Street is one of the most picturesque streets in South Boston, "the sunny street that holds the sifted few," to borrow Oliver Wendell Holmes's oft-quoted description of Beacon Street. Titled "K Street looking toward Ninth St.," this postcard was produced before March 1, 1914, when East Ninth Street between I and M Streets was renamed Marine Road. Residential postcards are comparatively scarce, as publishers encouraged their photographers to concentrate their efforts on local points of interest and landmarks, thus the prevalence of cards featuring Fort Independence, the Head House, Broadway, and the Dorchester Heights Monument. This practice was not limited to Southie—one can search for postcards depicting Louisburg Square on Beacon Hill, Union Park in the South End, Melville Avenue in Dorchester, Monument Avenue in Charlestown, and other prestigious addresses to no avail. Of the 300-plus postcards in the author's collection, only six are exclusively residential, and K Street is the subject of four of them.

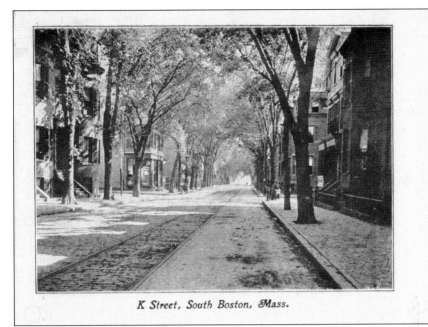

K Street, South Boston, Mass.

Various photographs from *The Illustrated History of South Boston* by C. Bancroft Gillespie, published in 1900, and *The History of South Boston*, compiled in 1901 by John J. Toomey and Edward P. B. Rankin, were obtained by publishers and used to produce postcards. An example is the upper card here, the view of K Street looking south from East Fourth Street, taken around 1899. This card, incidentally, was addressed to a Miss Collins of 928 East Broadway (the large, white Second Empire dwelling at the corner of P Street and Broadway), one of the four daughters of liquor merchant James Collins.

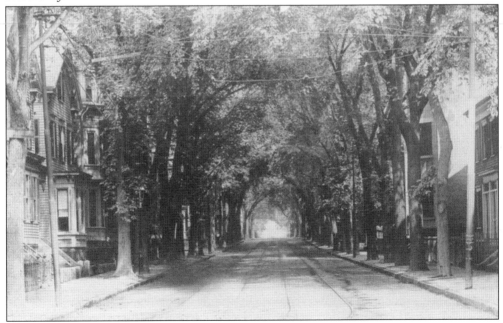

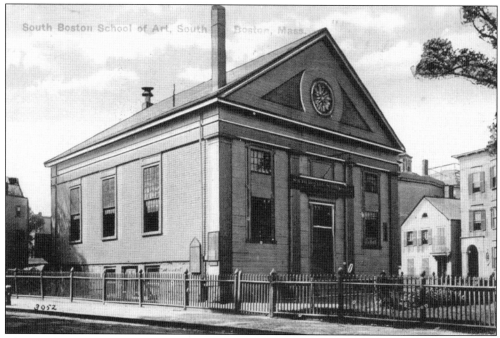

The South Boston School of Art was established in the old Hawes Place Congregational Society building at the intersection of East Fourth and Emerson Streets. According to John J. Toomey and Edward P. B. Rankin, the curriculum included "instruction in mechanical and freehand drawing, draughting, modeling in clay, yacht designing, stenography and several other equally interesting and important studies." The building burned in the early evening of February 4, 1963.

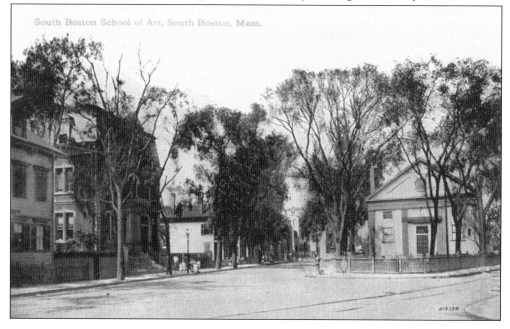

The Lincoln School, a four-story redbrick structure with 13 classrooms, stood on East Broadway on the current site of the South Boston branch of the Boston Public Library. Erected in 1859, it was named, as was customary, after a politician, Frederick W. Lincoln, mayor of the city from 1858 to 1860 and 1863 to 1866. It was shut down in 1947 and leased for a time to the Edward J. Troy Post of the American Legion, then demolished in 1952.

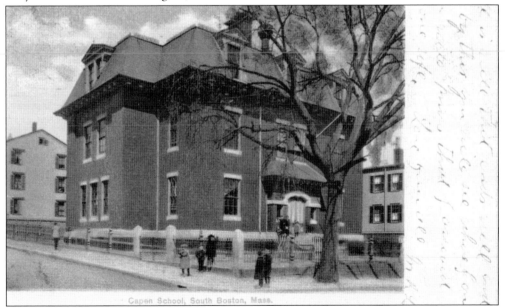

The three-story Capen School, erected in 1871 and comprising only six rooms, was named in honor of clergyman Lemuel Capen, a member of the school committee and a longtime resident of the immediate neighborhood. Located at the corner of East Sixth and I Streets, it was purchased by the archdiocese in 1945, renamed St. Peter's, and functioned as a parochial school until 2002. It, too, has been sold to a developer for the purpose of conversion to condominiums.

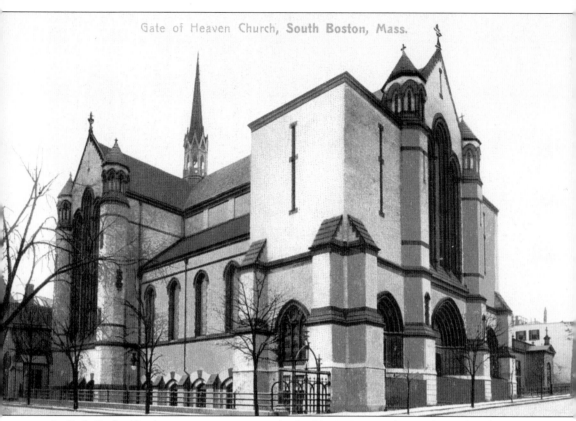

As Catholic families became more numerous in the City Point area during the mid-19th century, it became evident that a church would have to be built to accommodate them. The original Gate of Heaven Church was put up in 1863 on East Fourth and I Streets. The congregation continued to expand, however, necessitating a larger structure. On October 4, 1896, the cornerstone of the new building was laid, and on June 17, 1900, the church was open for worship. Although it was still under construction, John J. Toomey and Edward P. B. Rankin wrote, "The edifice is constructed after the thirteenth century type of Gothic architecture, of buff Roman brick, with brownstone trimmings. It has a frontage on East Fourth Street of 106 feet, a depth of 184 feet, and with its great height and other conspicuous points presents an imposing appearance." Work on the church was finally completed in 1912, and it was dedicated by William Cardinal O'Connell on May 12 of that year. St. Michael's Hall is visible on East Fourth Street to the right of the church.

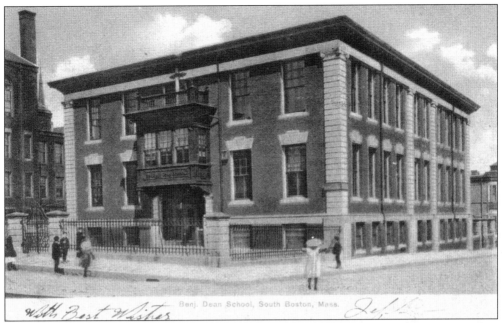

Benj. Dean School, South Boston, Mass.

With Best Wishes

School construction struggled to keep pace with the burgeoning student population of the late 19th century. The Thomas N. Hart School was completed in 1889 but was unable to accommodate the influx of new students. Shortly thereafter, in 1898, the Benjamin Dean Primary School was erected at the corner of East Fifth and H Streets, directly behind the Hart School. The Dean school was named after a former congressman from South Boston.

Describing the topography of the district, historians Toomey and Rankin wrote, "Originally, South Boston was much higher than it is at present and at frequent intervals, hills of considerable height rose from its surface." As this photograph reveals, sections of the neighborhood were still being leveled as recently as 1897. The Hart and Dean schools are visible in the background. (Courtesy of Bob Healey.)

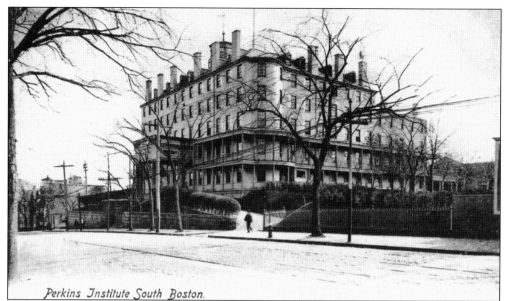

Perkins Institute South Boston.

The history of the Perkins Institute for the Blind has been well represented. Founded in 1829 by Dr. John Fischer, it was the first instructional school for the blind in the United States. The school's development in the 19th century was directed by Dr. Samuel Gridley Howe, who secured a generous endowment from philanthropic China trade merchant Thomas H. Perkins, after whom the school was named. Later the institute moved into the former Mount Washington Hotel. The accomplishments of several students, most notably Laura Bridgman and later Helen Keller, under the tutelage of Howe and Anne Sullivan, respectively, attracted teachers from as far as Paris and Edinburgh. The school, which was situated on Broadway between G and H Streets on the site presently occupied by the South Boston District Courthouse, relocated to Watertown in 1912.

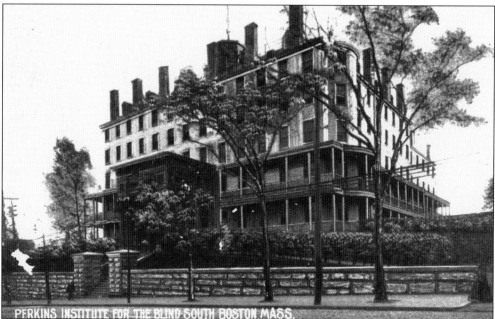

PERKINS INSTITUTE FOR THE BLIND SOUTH BOSTON MASS.

Five

DORCHESTER HEIGHTS

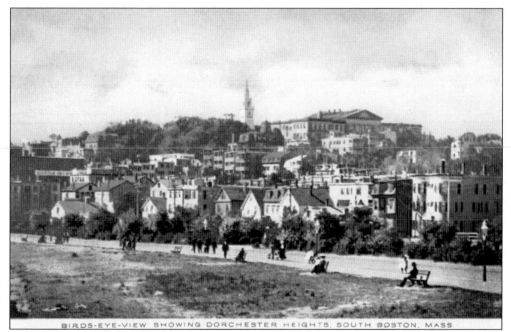

BIRDS-EYE-VIEW SHOWING DORCHESTER HEIGHTS, SOUTH BOSTON, MASS.

South Boston High School and the Dorchester Heights Monument overlook Telegraph Hill in this photograph, taken from Columbia Road near the foot of H Street, around 1915, in what is described as a "bird's-eye-view showing Dorchester Heights" (a very low flying bird, presumably). The row of houses, gaslights, and benches that beautified Columbia Road have disappeared over time, replaced by apartment buildings and condominium units. Revisiting the scene today, the landscape is dominated by the high-rise at 1410 Columbia Road. In 1971, the city zoning board authorized construction of a 17-story apartment building in the face of stiff neighborhood opposition. Incongruously positioned at the foot of G Street and Columbia Road, the monolithic structure was an effort by the federal government's Department of Housing and Urban Development to increase affordable housing for low-income residents.

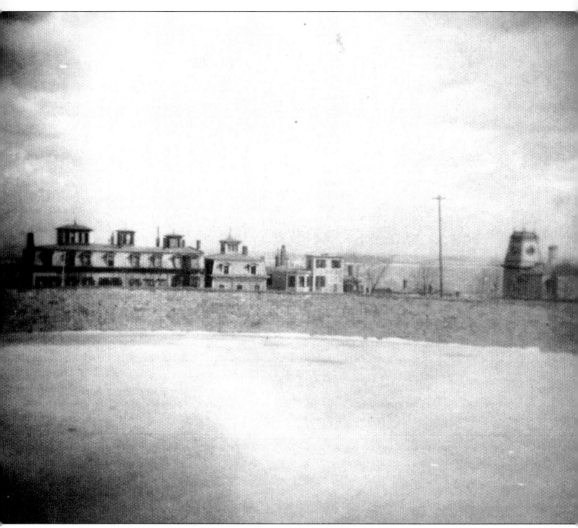

There may be other photographs of the reservoir that occupied the space where South Boston High School is built, but this *c.* 1896 photograph is the only one the author has ever seen. Prior to 1849, residents were supplied with water drawn from local springs and wells, which eventually proved inadequate. The reservoir was constructed that year on the eastern side of the hill and described as "lined inside with granite rubble, and the bottom paved with paving stones. It resembled in shape a segment of an ellipse, measuring, at its widest part, 370 feet and 260 feet at the narrowest. It had a capacity of 7,508,246 gallons." The remaining portion of the hill was then leveled and a scenic park laid out. Embellished by grass plots, seeded slopes, gravel walkways, and shade trees and circumvented by an iron fence, it was subsequently named Thomas Park after Col. John Thomas, who commanded the detachment that defended the hill during the siege and evacuation of Boston by British troops in March 1776. Upon completion of the project, a ceremony was held on November 20, 1849; the assembled multitude included Mayor John P. Bigelow and hordes of enthusiastic schoolchildren.

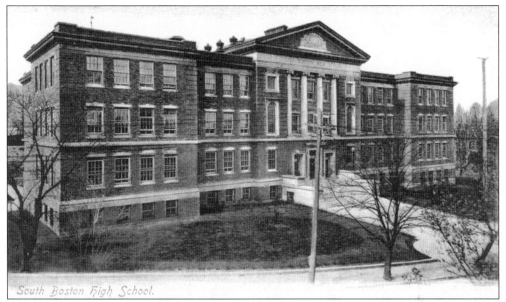

South Boston High School.

The reservoir was removed in 1897 to make room for South Boston High School. Designed by architect Herbert T. Hale, with a skyline modeled after that of the White House, the four-story Colonial structure opened in September 1901. Constructed of ochre brick with Indiana limestone trimming, the school is situated on the highest point in South Boston, overlooking City Point and the harbor. The classical facade is capped by a large stone pediment in which is carved the seal of the city, with allegorical figures of youth on each side. The contract set the cost of construction at $242,971, but actual cost upon completion was closer to $300,000. The dedication of the high school on November 26, 1901, was the culmination of 11 years of concerted effort by South Boston citizens.

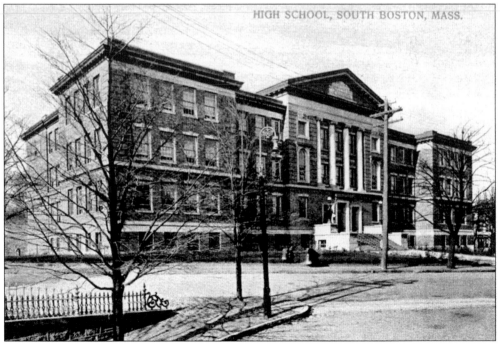

HIGH SCHOOL, SOUTH BOSTON, MASS.

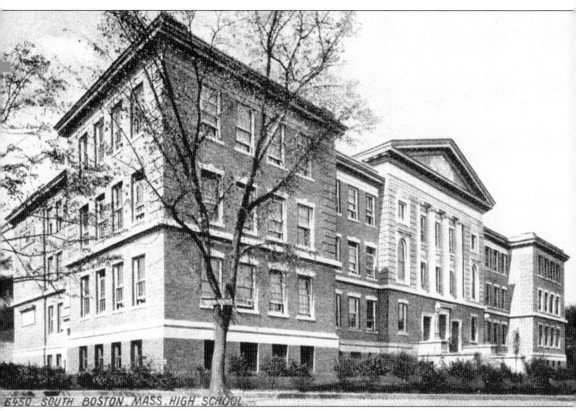

6450 SOUTH BOSTON, MASS. HIGH SCHOOL

The school building typifies the attention to detail characteristic of early-20th-century edifices. Sixteen granite steps ascend to an entrance comprising three double doors, which in turn lead to a spacious vestibule of white and Knoxville marble. A mosaic on the lobby floor features a lamp encircled by a laurel wreath of inlaid brass. The first floor included a gallery overlooking the gymnasium and drill hall, double classrooms at each front corner, and eight single classrooms. On the second floor, laid out similarly, were found the headmaster's office, library, and assembly hall with a seating capacity of 1,000. Laboratories for teaching chemistry, zoology, botany, physics, and drawing, as well as a large lecture hall were contained on the third floor. Moreover, each classroom was equipped with a new innovation—the telephone—connected to the main office. The 60-by-77-foot gymnasium, locker rooms, bicycle rooms, kitchen, cafeteria, and custodians' quarters were housed in the basement. To accommodate escalating enrollment, the south wing was built in 1926, the north wing in 1937; sheet metal shops were added onto the rear in 1940.

S, ARTHUR W.
TT, WILLIAM B.
LO, PETER E.

LORD, ORL
WINTERT(
WISE, CE

09 DONOVAN, JOHN H. '15
 DOOLEY, JOHN J. '12
 DOYLE, WILLIAM E. '12
 DRAHEIM, JOHN H. '13

KERRIGAN, JAMES B. '10
KILEY, JOHN F. '18
KINDER, EDWARD H. '16
KOPT, JOSEPH F. '13

This monumental oak cenotaph is mounted in the high school to commemorate the sacrifices made by graduates of South Boston High School who served in the armed services during World War I. It is no exaggeration to state that, as an artistic achievement, it is probably unsurpassed by any original work of art in any public secondary school in America. Those who find this statement hyperbolic should reserve judgment until viewing it firsthand. Masterfully carved of quartersawn oak by a supremely skilled artist, it measures fully 11 feet high by nearly 7 feet in width, with 214 names incised into the surface. Six of the soldiers listed were killed in action. Its creation was funded by the Works Project Administration, or WPA, an employment program administered by the Roosevelt administration from 1937 to 1943 as an effort to alleviate the pervasive unemployment of the Depression.

FORRESTER B. WASHINGTON, A.B., A.M.

It may come as a surprise to some to learn that the president of the South Boston High School class of 1905 was an African American. Forrester B. Washington (1895–1963) of 390 East Eighth Street attended the Thomas Hart School and was among the first group of 500 students that enrolled when the high school opened in September 1901. He went on to graduate from Tufts University in 1909, undertook postgraduate study at Harvard, then taught modern languages and chemistry at Howard University. In 1916, he obtained a master's degree in social economics from Columbia and from there established himself as a driving force in the developing field of social work. A vociferous proponent of self-reliance for blacks, Washington eventually attained a position in Pres. Theodore Roosevelt's informal "Black Cabinet," although he would later resign his post over a policy dispute. Subsequently, he assumed leadership roles at the Urban League chapters in both Detroit and Atlanta and became the first dean of the Atlanta School of Social Work. He is remembered today as a man who deftly transcended the societal limitations of the times and became a catalyst for racial equality and social justice.

A weary Dr. William Reid descends the steps after yet another day of frustration at Southie High in December 1975. The erudite Reid, headmaster from 1965 until December 1975, was a graduate of Boston Latin and Dartmouth College, a recipient of the Bronze Star for heroism during World War II, the author of four books, and an iconic figure in the neighborhood. Despite the fact that he was an active exponent of the thesis that education is the right of every student, regardless of color, he was summarily removed by federal district court judge Wendell Arthur Garrity for failure to implement his directives. Garrity blamed Reid for the shortcomings of his desegregation plan. After his dismissal, Reid finished out his distinguished career mentoring other principals. He passed away in 2006, still remarkably lucid and articulate at 94. After 10 years and 415 decisions, Garrity left the Boston public schools far more segregated than the system he took over. He went to his grave in 1999.

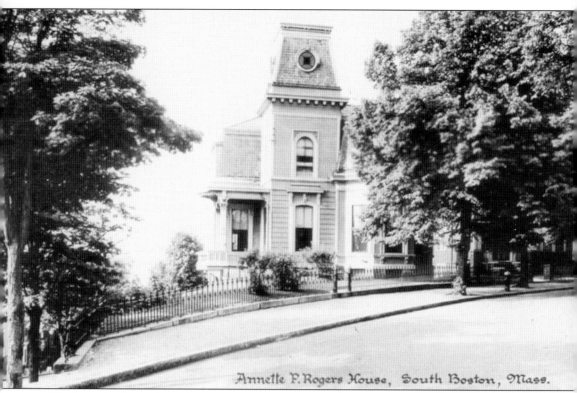

Annette P. Rogers House, South Boston, Mass.

The imposing Second Empire structure at 69 Thomas Park with its towerlike mansard square bay, projecting bowed roof, and segmented arched widows was built in 1875 by Thomas Manning, a successful cotton broker. After his death in 1893, it was purchased by Samuel W. Johnson (1851–1925), a prolific developer of triple-deckers from 1890 to 1910. Johnson is credited with the construction of approximately 200 homes in South Boston, "during which time he has done more towards improving property in this district than any other man." Inexplicably, he moved to Jamaica Plain in 1916, and the structure was acquired by the Massachusetts Society for Promoting the Interests of the Adult Blind as a residential home for providing job training to the visually impaired, many of whom had attended the Perkins Institute. The building served this function until 1946. One might logically assume that Annette P. Rogers owned the home; on the contrary, she lived her entire life at 5 Joy Street on Beacon Hill. Rogers was an indefatigable activist for the plight of the less fortunate who passed away in 1920, leaving a substantial bequest to charitable causes, and the home was named in her memory.

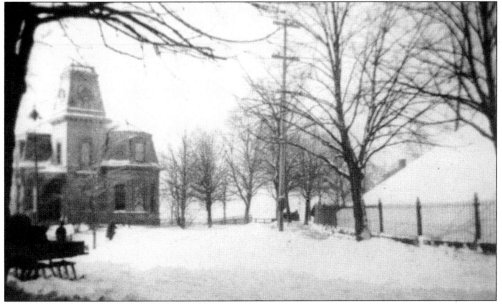

In this photograph, taken about 40 years prior to the preceding image, a heavy blanket of snow covers G Street, which is atypically devoid of cones and barrels. The Johnson home is at left. Note the sloping incline at right, which lead to the reservoir. Within a couple of years, the reservoir would be filled in and the eastern slope of Dorchester Heights leveled in preparation for the construction of South Boston High School.

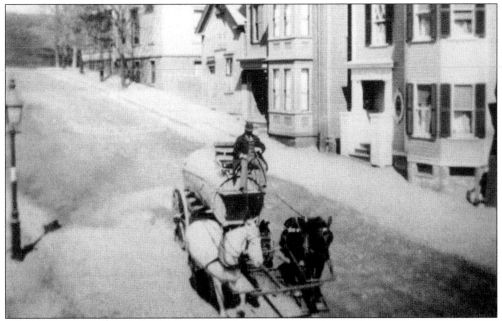

This photograph also antedates the existence of the high school, as the periphery of the reservoir is visible at upper left. Here, pulling a carriage and cylindrical water tank, a team of dray horses saunters down East Sixth Street on a sunny morning in 1896. The function of a water wagon was to wet down the street in order to prevent dust from rising, a common practice before paved streets became the norm. (Courtesy of Bob Healey.)

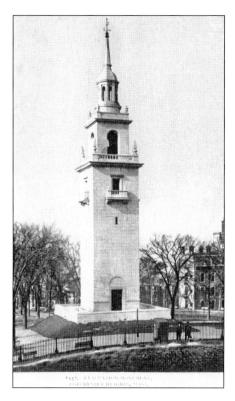

In compliance with residents' desire to commemorate the evacuation of Boston by British troops under the command of Gen. William Howe on March 17, 1776, the sum of $25,000 was appropriated on June 14, 1898, for the purpose of establishing a monument on Dorchester Heights. A committee was appointed by Gov. Alexander Rice to oversee the project, and on May 10, 1899, a competition for designs was announced. Eight plans were submitted for consideration, and the design of the architectural firm of Peabody and Stearns was selected.

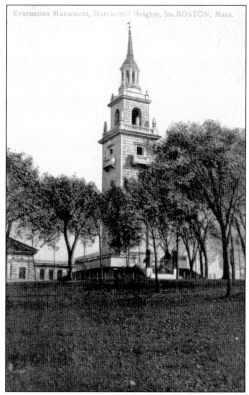

Peabody and Stearns's design incorporated the basic form and proportions of the Colonial meetinghouse steeple. Constructed entirely of white marble, the monument is approximately 115 feet in height from its base to the top of the vane. A square base supports the main shaft, about 60 feet in height, the top of which forms a platform that is surrounded by a balustrade. This platform affords an unsurpassed view of the harbor and city. A second square shaft, smaller in diameter, rises from the platform, atop which is mounted an octagonal platform. On the eastern side of the base, a broad stairway leads to the entrance; on the west side is affixed a marble panel with an inscription composed by Dr. Charles D. Eliot, president of Harvard University.

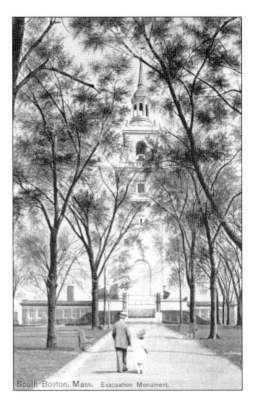

South Boston, Mass. Evacuation Monument.

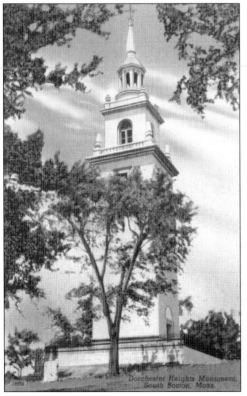

Dorchester Heights Monument,
South Boston, Mass.

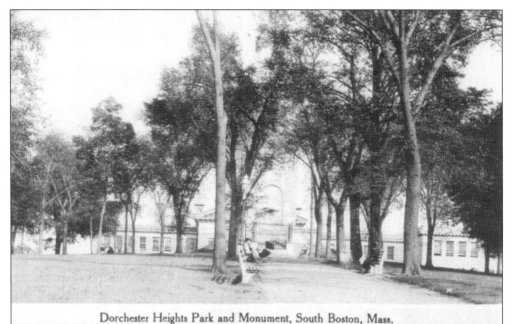

Dorchester Heights Park and Monument, South Boston, Mass.

A parade through the streets of South Boston heralded the unveiling of the Dorchester Heights memorial on March 17, 1902. A military band played "The Star-Spangled Banner," after which Gov. Winthrop Crane briefly addressed the assembled multitude, observing that, "from that day to this, the soil of Massachusetts has not been pressed by the foot of a foreign foe." The tablet on the marble shaft, which was covered with American flags, was then unveiled to the stirring lyrics of "America." Additional formal ceremonies were conducted in the assembly hall of South Boston High School, including a prayer offered by the Reverend William F. Warren and a lengthy speech by United States senator Henry Cabot Lodge, an orator of apparently limitless endurance.

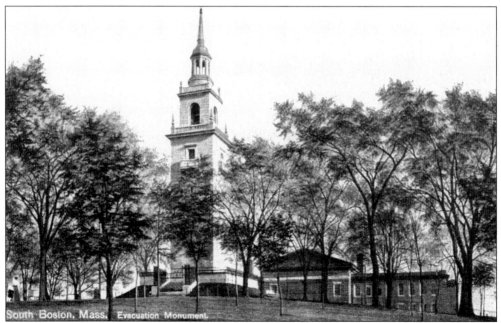

South Boston, Mass. Evacuation Monument.

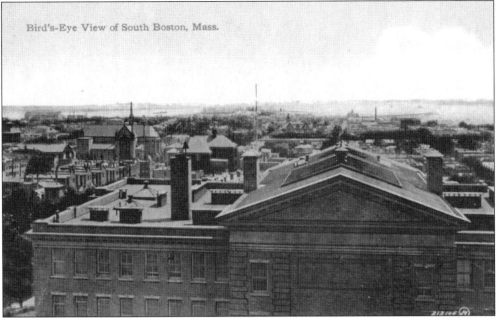

In the series of four postcards that follow, the photographer has positioned himself on the observation platform of the monument, first facing east and then rotating 360 degrees. In the upper card, looking directly east over the pedimented roof of the high school, the steeple of Gate of Heaven Church is visible to the left. The message transcribed on the back of the postcard, which is postmarked 1909, indicates that the church is "not yet finished inside."

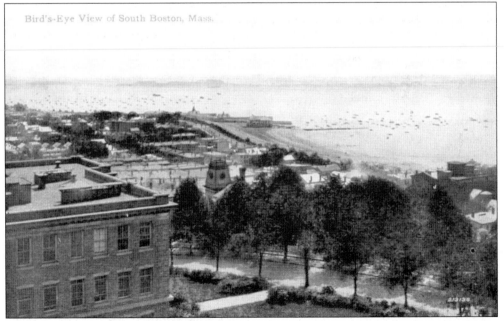

Now turning to the southeast from the same vantage point, the mansard bay of the Johnson house at 69 Thomas Park is evident in the left center of the card, just to the right of the high school. In scanning the shoreline, a large structure is visible on the beach, just this side of the L Street Bathhouse. This is a side view of the Mosquito Fleet Yacht Club.

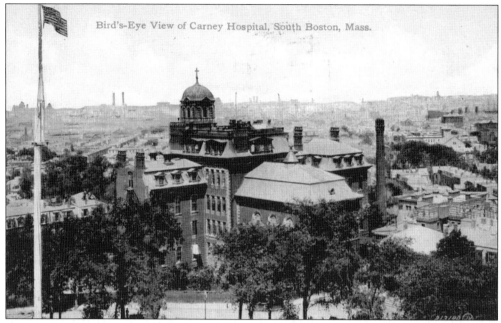

Depicted in the upper card is the rear of the Carney Hospital, with the western perimeter of Thomas Park in the foreground. In the lower card, the photographer has completed his turn to the right, capturing the northeastern quadrant of the district. Clearly evident at left is the steeple of the Hawes Unitarian Church (now the Albanian Orthodox Cathedral of St. George) on East Broadway, built in 1872, while in the center of the card stands the Perkins Institute for the Blind, about a decade before it was demolished in 1916.

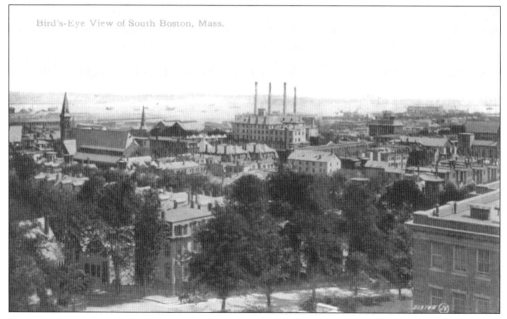

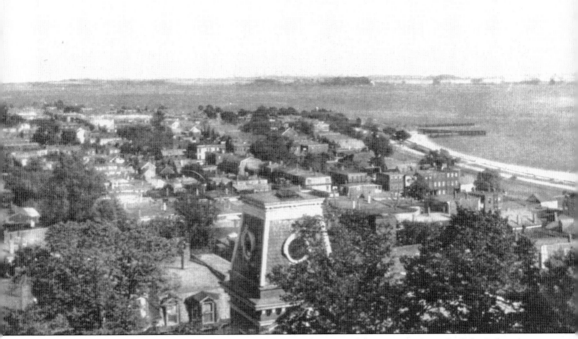

In the foreground of this vintage 1930s postcard is the towerlike mansard roof of the Johnson house (by then the Annette P. Rogers House) with its distinctive circular fenestration. It might appear, at first glance, that this shot was also taken from the Dorchester Heights Monument, but the high school's south wing was added in 1926, effectively blocking this view from the monument. More likely, this photograph was taken from room 302 of the high school. Surveying the shoreline again, it is apparent that the Mosquito Fleet Yacht Club has disappeared.

Prominently sited at the summit of Dorchester Heights, this magnificently flamboyant example of stick-style residential architecture at 56 Thomas Park is one of three spectacular mansard homes situated between the flights of steps and G Street. The facade is embellished by a single-story, three-sided bay window trimmed with Gothic colonettes and a two-story gabled bay. The fish scale patterned slate roof is surmounted by the structure's crowning feature, a square cupola with three-pointed, arched windows on each side. The cast-iron balustraded fence, grand central staircase, stained-glass portal, most of the original woodwork, and other architectural details, such as the lion-head brass doorknobs, are intact. Built in 1876, the home was originally owned by Frederick Walbridge, who ran a furniture and household goods emporium on Hanover Street and resided here with his family until 1898. It was then purchased by William S. Milligan, a successful hardware merchant, proprietor of a thriving hardware business on Atlantic Avenue near Dewey Square. This stunningly ornamental edifice has never appeared on a postcard, a grievous oversight on the part of postcard publishers.

Designed by city architect Charles Bateman, the Carney Hospital was built on the site of the former Howe estate with funds provided by Andrew Carney (1784–1864), who had emigrated from Ireland in 1794 and amassed a sizeable fortune as proprietor of the Carney and Sleeper clothing firm and president of the Bank of the Mutual Redemption. Carney purchased the Howe estate in 1863 and converted the erstwhile mansion, complete with greenhouse and orchard, into a hospital. Administered by the Sisters of Charity of St. Vincent de Paul, the hospital quickly outgrew the original facility, and the brick building pictured in these two postcards was completed in 1868. Carney passed away in 1864 at his residence at 57 Summer Street and never saw the fruits of his generosity.

South Boston, Mass. Carney Hospital.

The Out-Patient Building, Carney Hospital, South Boston, Mass.

The outpatient clinic of the Carney Hospital at the corner of Dorchester Street and Old Harbor Street, a handsome redbrick and limestone Colonial Revival structure, was built in 1901 at a cost of $91,000. A contemporary brochure states that the structure is "of a first class fireproof construction throughout, and for beauty and simplicity of arrangements is not surpassed by any Out-Patients in the country." By 1907, the Carney was the third-largest hospital in the city with 200 beds. That year, 2,600 patients were treated in the wards and 57,000 in the outpatient departments, many of whom were unable to afford medical care elsewhere. In the lower photograph, two sisters fill prescriptions in the pharmacy.

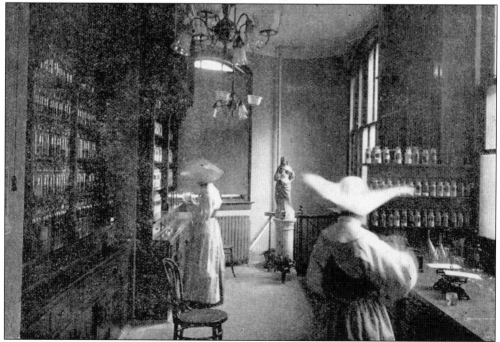

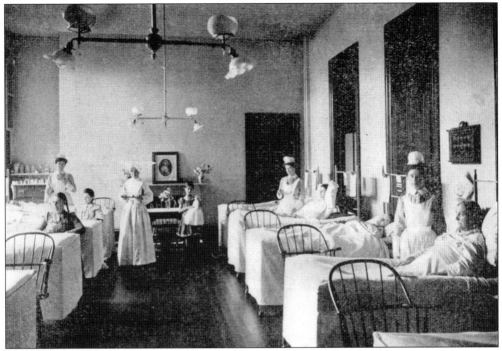

The Carney Hospital comprised many wards, including medical, surgical, ophthalmological, gynecological, and orthopedic. As seen in the upper photograph here, the laity also contributed to patient care as trained professional nurses, ably assisting the Sisters of Charity. The lower photograph shows a private room, which compares favorably with the level of spaciousness and comfort afforded by most modern hospitals.

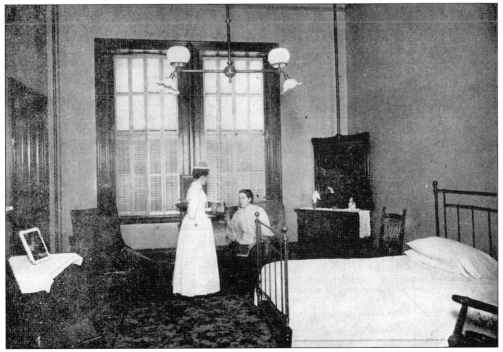

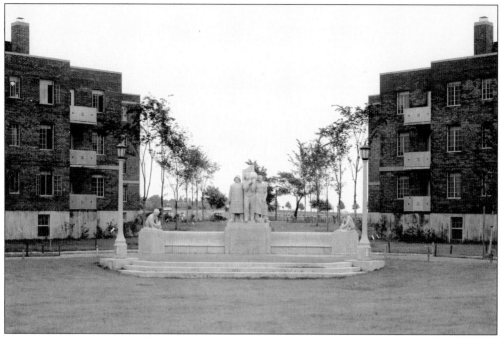

George Aarons's ensemble representation in stone of a longshoreman, fisherman, and foundry worker, flanked by a young boy and girl at play, graced the Old Harbor Village when the federal housing project opened in 1938. The dignity of the common man was a recurring theme in Aarons's work. In 1937, he was selected by the Treasury Relief Art Project, a WPA-funded entity, to create the monumental sculpture, which was 34 feet long and 15 feet high. It was dedicated by Mayor Maurice J. Tobin on Labor Day 1938. Sadly, vandals disfigured the statuary shortly after its installation; it was removed from the project about 10 years later. (Courtesy of Rebecca Reynolds.)

Six

PERKINS SQUARE
AND BROADWAY

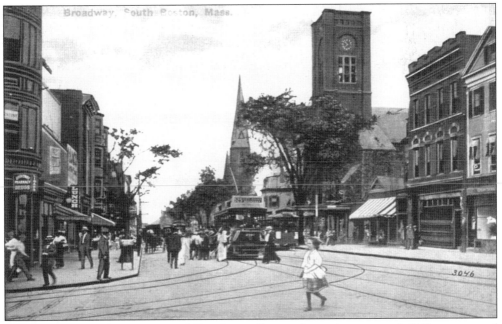

The intersection of Broadway and Dorchester Street, shown here around 1910, was named Michael J. Perkins Square as part of the St. Patrick's Day parade ceremony of 1920 to commemorate the extraordinary heroism of the Southie native who was awarded the nation's highest award for bravery, the Congressional Medal of Honor, for demonstrating "conspicuous gallantry and intrepidity, above and beyond the call of duty." Raised in the Lower End, he resided at 171 West Seventh Street when he enlisted in 1916. On October 17, 1918, the 26-year-old Perkins's squad was engaged in a fierce firefight with German troops in Belleu Bois, France, its advance stalled by a fusillade of machine fire emanating from an enemy pillbox. Armed with only a knife and a grenade, Private Perkins crawled alone to the enemy position; the door of the pillbox would open intermittently and German soldiers propelled hand grenades at him. Waiting for the door to open again, he flung his own grenade, blowing the door open. Trench knife drawn, he rushed the pillbox and single-handedly killed or wounded several enemy combatants, subdued seven machine guns, and took 25 prisoners.

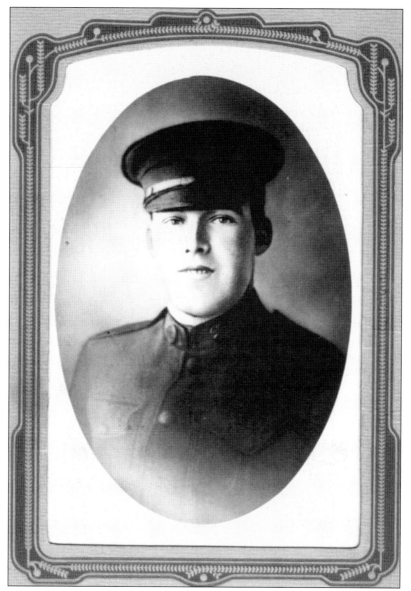

Pvt. Michael J. "Mickey" Perkins sustained an injury to his arm during the assault and was ordered to the infirmary to have his wounds dressed. Tragically, the ambulance speeding Perkins to the field hospital was struck by a shell, instantly killing its occupants. A very different story, perhaps apocryphal, perhaps not, emerged after the war. Fr. James P. Sherry, pastor of St. Anthony's Church in Cohasset, former chaplain of the 102nd Infantry, confided to the family that he had actually been the one who discovered Mickey's body. After being sent for treatment, Mickey had apparently survived the explosion of the ambulance and made his way back to the front. Father Sherry found his body in the midst of another machine gun emplacement, surrounded by the corpses of six Huns and an unmanned machine gun, but Mickey had himself sustained a fatal head wound. Sometimes, even after "the Fog of War" lifts, the truth can be elusive. No matter which version of the young soldier's demise one accepts, there is no question but that Michael J. Perkins takes his place with Audie Murphy and Alvin York in the pantheon of truly exceptional American fighting men. (Courtesy of Alicia Mulkern Hawkes.)

GEN EDWARDS AT DEDICATION OF MICHAEL J. PERKINS SQ

WITH GEN EDWARDS ARE SEEN THE FATHER, MOTHER, SISTERS AND BROTHER OF THE SOUTH BOSTON HERO.

Ironically, the engagement in which Mickey Perkins was killed took place only 16 days before the armistice was signed. Still, it would be three years before his remains were returned to Boston for a proper burial. An estimated 100,000 mourners paid their last respects as his body lie in state, one of the largest funereal gatherings in the city's history, and a high requiem mass held at St. Augustine's church on October 10, 1921. His body was laid to rest in New Calvary Cemetery. The medals have been handed down from his youngest sister, Jean, to her son, Jim Barry of Marshfield, who donated them to the Yankee Division Military Museum in Worcester, where they are now prominently displayed. These include the Congressional Medal of Honor, the Purple Heart, the Croix de Guerre conferred by France and the Croce de Guerra awarded by Italy. (Above, courtesy of the Boston Globe.)

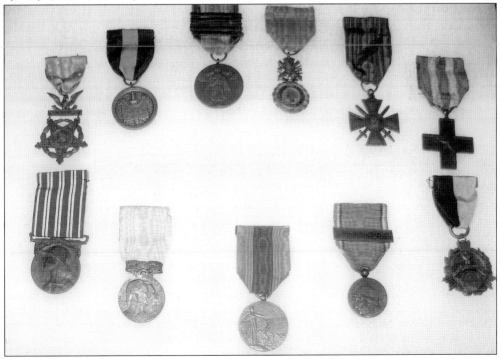

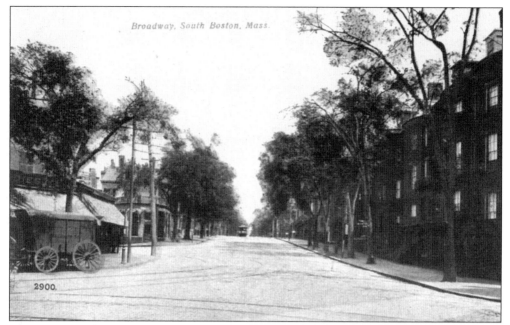

These images of East Broadway, taken from antipodal perspectives, clearly display the mixed use of residential and commercial properties that define the thoroughfare. Looking east from the juncture of Broadway and Dorchester Street in the top card, the row of brick bowfronts at right lends an air of elegance and harmony to the area. In the lower card, facing west toward Flood Square, it is possible to position the photographer from the trolley tracks that curve onto K Street. Commenting on the track patterns of the era, transportation archivist Leo Sullivan averred, "It would be difficult to find a picture of Broadway from this period that didn't have trolleys in it." The postcards presented here demonstrate the veracity of this assertion.

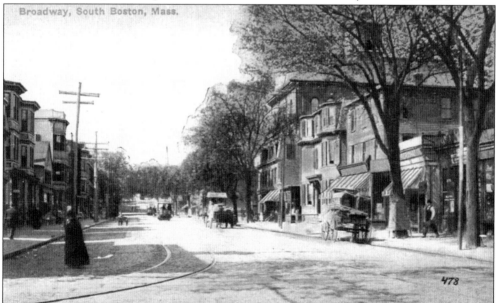

A pair of enterprising grocers stands ready to greet customers in front of their Flood Square emporium, around 1910, which is festooned with bunting for St. Patrick's Day. Someone has transcribed the phrase "So. Boston: Some class!" on the card, as well as "bananas 10 for 25¢." On the reverse, the writer estimates the number of parade watchers at one million but strains credulity with the observation that "the huge crowd has been drinking for days," doubtless a gross exaggeration as such vulgar displays of public intoxication have always been socially unacceptable in Southie.

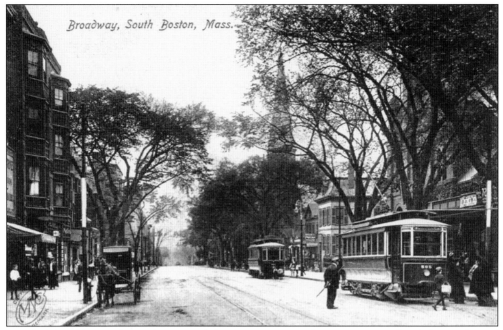

The bustle of horse-drawn buggies, delivery wagons, and streetcars testify to the vitality of West Broadway's business district, around 1906. To the right, the spire of St. John's Methodist Church points skyward, and the distinctive oblong steeple of the Phillips Congregational Church is clearly evident. After construction of the Andrew Square Red Line station in 1919, two years after Broadway Station was completed, streetcar traffic on Dorchester Avenue was reduced significantly. Trolley service from South Boston to North Station continued until 1953.

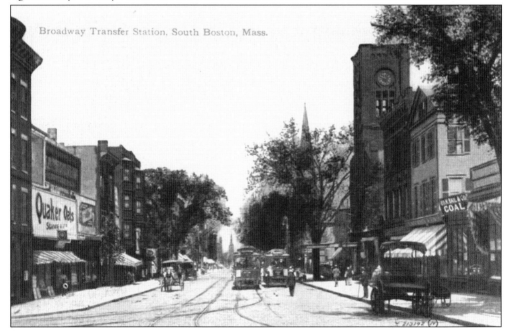

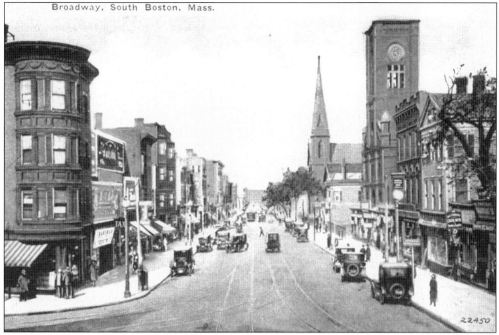

The commercial properties on West Broadway have changed very little in this white-border postcard, which was printed at least a decade after the preceding two cards. However, the horse-drawn carriages have been replaced by automobiles, which, even then, jockeyed for parking spaces. The bottom card is one of only two examples of a linen surface postcard to appear in this book. Published in the 1940s by the J. B. Clarke Company of 383 West Broadway, it bears a 1951 postmark. By this time, the street is more heavily congested with vehicular traffic.

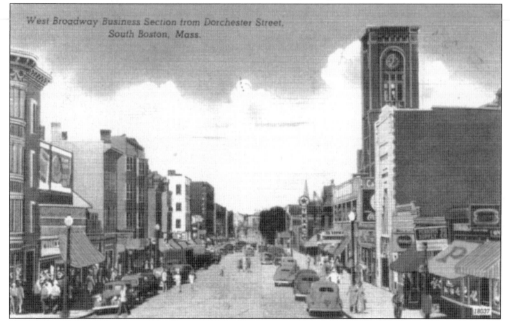

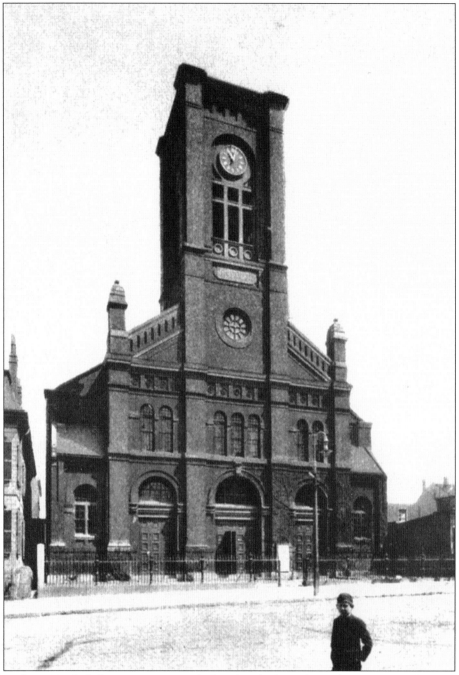

When the original Phillips Congregational Church, which was located at A Street and Broadway, was being built in 1835, the city had tentatively made plans to name the streets perpendicular to Broadway after previous Boston mayors. Expecting the intersecting street to be renamed after the city's first mayor, John Phillips, the church adopted this name, not bothering to change even after the plan was discarded and the cross streets named alphabetically. Congregants even retained the eponym after the structure pictured here was built at a different Broadway location, between F and Dorchester Streets, in 1859. The church was torn down in 1948.

Seven

The West Side
and Lower End

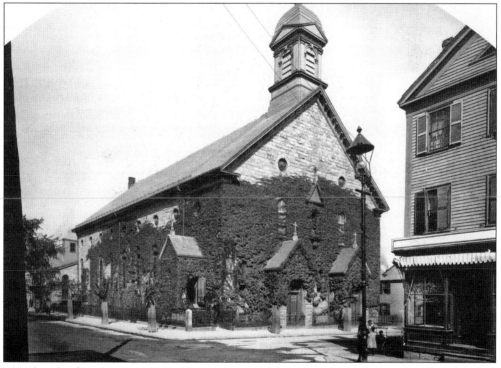

The church of St. Vincent de Paul has an unusual history in that it is one of the few churches that actually followed its parishioners from one section of the city to another. In 1872, the city was ravaged by a fiery holocaust that incinerated most of Fort Hill, home to the poorest of the city's "Famine Irish" population. Many of the displaced moved in with family and friends in Southie's Lower End. Portions of the surviving structure, which had been built by Unitarians in 1825 but purchased by Andrew Carney for the Catholic archdiocese in 1848, were carted to West Third and E Streets in 1872 and used in construction of the new edifice. Upon completion, a painting of the Crucifixion from the original house of worship was placed over the main altar and the old bell installed. The new church was formally dedicated at a solemn high mass on July 19, 1874, only a couple of months before the dedication of St. Augustine's. (Courtesy of Historic New England.)

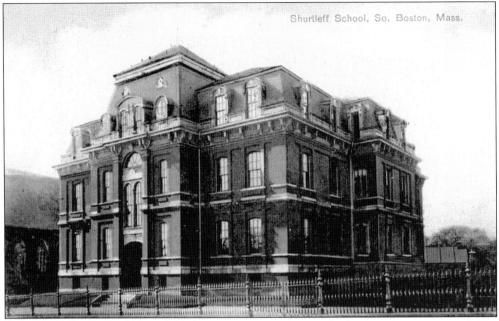

Overcrowding at the Bigelow created urgent demand for a new school, and construction of the Shurtleff Grammar School on Dorchester Street was completed in 1869. Girls from the Bigelow School were subsequently transferred to the Shurtleff. The school was named after Nathaniel B. Shurtleff, mayor of Boston from 1868 to 1870. It was abandoned and demolished in 1935 and replaced by the Patrick Gavin Middle School.

At the beginning of the 20th century, the teaching profession was dominated by women. According to historian Thomas H. O'Connor, they were "severe in appearance, modest in dress and completely dedicated to their profession . . . strict disciplinarians who ruled their classes with an iron hand." The matronly pedagogue portrayed here in classroom No. 2 of the Joseph H. Clinch School, around 1897, would appear to fit O'Connor's description.

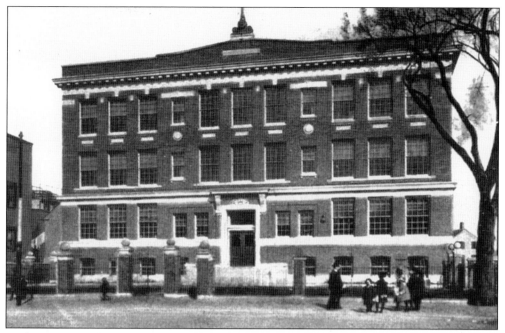

Built in 1905 at the corner of Dorchester and Middle Streets, the three-story, 13-room John Boyle O'Reilly School was named after the outspoken Fenian agitator, Australian penal colony escapee, and lifelong Irish nationalist who found his niche in Boston as an influential writer, lecturer, poet, and editor of the widely read *Pilot*. The school was closed in 1981 and reconfigured into apartments for the elderly.

St. Monica's parish was established in 1900 as a chapel for St. Augustine's and officially designated a parish under the pastoral direction of the Reverend Timothy J. Mahoney in 1907. The wooden structure at 385 Dorchester Street served parishioners in Andrew Square until 1956, when a new church was built on Old Colony Avenue next to the Mary Ellen McCormick housing development.

Pres. Theodore Roosevelt once declared, "If I were to pick one man for my sons to pattern their lives after, it would be Jim Connolly." It is easy to understand his choice of Connolly—the world-class athlete, soldier, seafarer, adventurer, diplomat, and acclaimed novelist crammed several lifetimes of experiences into one. The sixth of 12 children born to immigrant parents from the Aran Islands, off the west coast of Ireland, James Brendan Connolly (1868–1957) grew up in the Lower End and attended local schools, among them the Lawrence, and eventually passed the entrance exam for Harvard, where he matriculated in 1895. Having already won the Amateur Athletic Union national title in the triple jump, he resolved to compete in the revival of the Olympic Games in Athens in 1896. He petitioned Harvard administrators for a leave of absence but was denied. He left anyway. In Athens, he captured the first gold medal awarded and placed in two other track events, taking three medals overall. Fifty years later, possibly to make up for their earlier intransigence, Harvard offered Connolly an honorary doctorate; he declined. (Courtesy of Colby College Special Collections.)

Connolly's family, originally from the Lower End, had moved to 188 E Street, then 690 East Fifth Street while he attended Harvard. Upon returning from Athens, he boarded at 82 H Street and 147 L Street while pursuing a career as a journalist. But he craved travel and adventure and when the Spanish-American War broke out, enlisted in the 9th Massachusetts Infantry and survived the siege of Santiago. He became a war correspondent during World War I and was appointed commissioner for relief of Ireland during the "Black and Tan" upheavals. He eventually settled in Gloucester and became America's preeminent writer of maritime tales, writing 25 full-length books and over 200 short stories. No less an authority than Arthur Daley of the *New York Times* lauded Connolly as "the most distinguished author of sea stories in the land." He passed away after a long illness at the Veteran's Administration Hospital in Jamaica Plain at age 88. (Courtesy of Colby College Special Collections.)

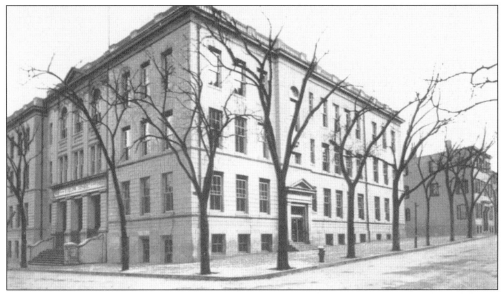

In 1899, the original Bigelow School at F and West Fourth Streets was razed in order to install the upgraded facility pictured here, which was comprised of 17 classrooms, a science room, an exhibition hall, and a library. Constructed of buff brick and trimmed with Warsaw bluestone, it was named after the Honorable John P. Bigelow, mayor from 1849 to 1851. The school closed in 1975 and was subsequently sold for conversion to condominiums.

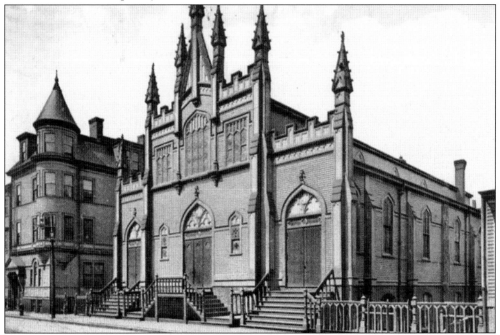

The Church of Our Lady of the Rosary was built on West Sixth Street in 1884. Unlike most Catholic churches built during this era, the exterior was constructed of wood and featured a new innovation—electric lights. In 1941, the church and the surrounding neighborhood were slated for destruction when plans were developed for a massive public housing project, comprising six square blocks, in the Lower End. The final mass was conducted on February 6, 1942.

BLINSTRUB'S VILLAGE

DINE & DANCE FLOOR SHOW

300-308 BROADWAY, SO. BOSTON, MASS.

In 1968, just 26 years after the Cocoanut Grove holocaust, another Boston entertainment landmark burned to the ground. Blinstrub's Village, located at 308 West Broadway (the corner of D Street, currently the site of the Shell station), is described on the reverse as "America's Largest Niteclub" with "a seating capacity of 1100" and "unlimited free parking." The club featured performances by the most popular entertainers of the day, including, Patti Page, Al Martino, Johnny Mathis, Wayne Newton, Robert Goulet, Frankie Lane, the McGuire Sisters, Tony Bennett, Nat King Cole, and many, many others. It was never rebuilt because proprietor Stanley Blinstrub neglected to carry insurance.

Blinstrub's

FLOOR SHOWS & DANCING NIGHTLY
308 Broadway, South Boston, Mass.
SOuth Boston 8-5440

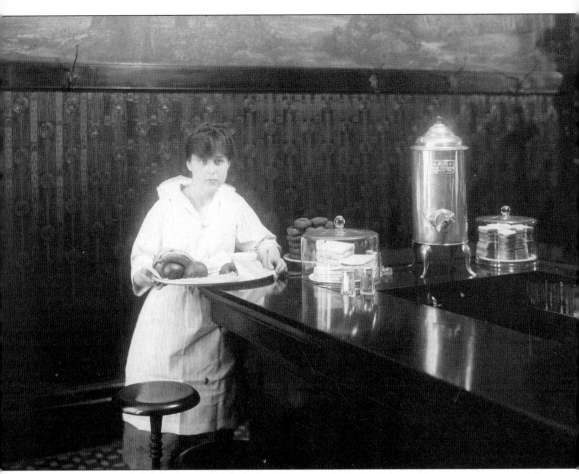

This photograph was not a postcard, but it should have been. Postcards that featured people as the subject generally portrayed celebrities—heavyweight champion Jack Dempsey or actress Mary Pickford, for example. This photograph by Lewis Wickes Hines, taken in 1911, is entitled "Delia Kane, 99 C Street, South Boston." Although the subject is not famous, the photograph merits attention because her face reflects the optimism and uncertainty of a young woman, possibly an immigrant or the child of immigrants, probably uneducated and laboring in a menial job, trying to make her way in the world. Hers is the story of South Boston, the story of America, then and now. (Courtesy of the Library of Congress, Department of Prints and Photographs.)

This cabinet card of a smartly attired young man posed with an Eastlake mahogany settee and winged griffin mantel as props is typical of the portraiture produced by Victorian-era photographers. Arthur Latto maintained a successful studio in South Boston for nearly 30 years in the latter decades of the 19th century. Between 1872 and 1874, he operated out of 242 West Broadway, then moved to 202 West Broadway, where he remained until 1899. This card, then, dates to the last quarter of the century. For a time, Latto worked in partnership with the Rand brothers, George T. and John C., and cards turn up bearing the logo "Rand & Latto." Little is known of the Rand brothers, but Arthur Latto resided at several addresses on West Broadway as well as 853 East Fourth Street, 111 K Street, and 574 East Broadway.

S. S Peter and Paul Church and Rectory, Broadway
South Boston, Mass

Although masses were held at St. Augustine's chapel for the peninsula's growing Irish Catholic community, Bishop Benedict Joseph Fenwick described the building as "crowded to suffocation" and shortly thereafter bought land between the turnpike (now Dorchester Avenue) and A Street, in close proximity to the congested tenements of Irish laborers in the Lower End. In 1845, the church was completed and dedicated to SS. Peter and Paul. Only three years later, however, on September 7, 1848, the building was seriously damaged by fire and had to be rebuilt. Fortunately the church was adequately insured, and reconstruction was completed under the supervision of Fr. Patrick Lyndon. It was rededicated on Thanksgiving Day, November 24, 1853. The second-oldest Catholic church in Boston, it closed in 1995. Both the church and rectory now house condominium units.

Immigration from Ireland increased dramatically after the Civil War, and by 1880, there were almost 65,000 people born on Irish soil living in the city, approximately double the number of Irish born living here 30 years prior. Many were ensconced in South Boston, the most thickly settled section of which was the Lower End, between A and F Streets. This old photograph, which turned up at a flea market, portrays the apartment building at 72–76 West Broadway (across A Street from Amrhein's) on St. Patrick's Day 1901, which explains the bunting. The tavern on the first floor has long since disappeared. A former roommate of the author's, Joe Stappen, grew up in this building and expressed great skepticism that there had ever been a tavern on the first floor until shown this photograph. As this book goes to press, it has been reported that the block has been sold by the archdiocese to a developer who plans to raze the entire section, including the row houses on A Street, some of the last remaining tenements in the Lower End. (Courtesy of Joe Williams.)

Across America, People are Discovering Something Wonderful. *Their Heritage.*

Arcadia Publishing is the leading local history publisher in the United States. With more than 3,000 titles in print and hundreds of new titles released every year, Arcadia has extensive specialized experience chronicling the history of communities and celebrating America's hidden stories, bringing to life the people, places, and events from the past. To discover the history of other communities across the nation, please visit:

www.arcadiapublishing.com

Customized search tools allow you to find regional history books about the town where you grew up, the cities where your friends and family live, the town where your parents met, or even that retirement spot you've been dreaming about.